IMAGES
of America

LOS GATOS

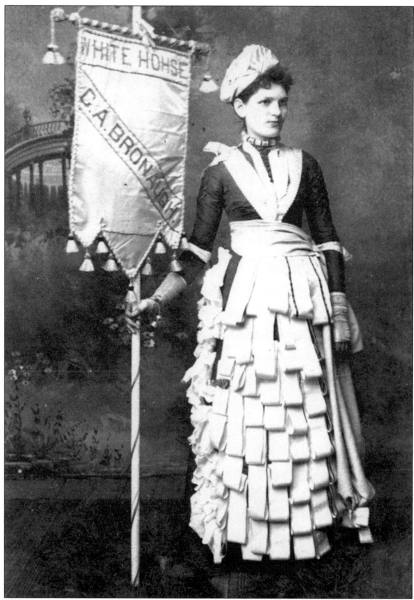

Louise Van Meter (1869–1948). Daughter of an early Los Gatos tinsmith, "Lulu" Van Meter participated in a "Merchants' Carnival" c. 1890, when she was in her early twenties. Each young woman designed her own outfit to represent her sponsor at this event held at the Presbyterian Church. The "White House" sold "Gents' and Ladies' Furnishings," as well as notions, which resulted here in a necklace created from spools of thread. Memories of the Civil War were still fresh, and the women performed a military drill, led by an officer of the Grand Army of the Republic. A dedicated and beloved teacher, Miss Van Meter taught first grade in Los Gatos for 35 years. She lived with her mother in a small Victorian cottage at 266 East Main Street and is remembered for bringing the concept of kindergarten to Los Gatos. She was a member of the History Club of Los Gatos and could be seen driving around town in a sporty Model A coupe. The decision to name the new elementary school after her came just before her death in 1948.

IMAGES
of America
LOS GATOS

Peggy Conaway

ARCADIA

Published by Arcadia Publishing
Charleston SC, Chicago IL, Portsmouth NH, San Francisco CA

Printed in Great Britain

Library of Congress Catalog Card Number: 2004104891

For all general information contact Arcadia Publishing at:
Telephone 843-853-2070
Fax 843-853-0044
E-mail sales@arcadiapublishing.com
For customer service and orders:
Toll-Free 1-888-313-2665

Visit us on the internet at http://www.arcadiapublishing.com

For Harry C. Meserve, who loves trains and history.

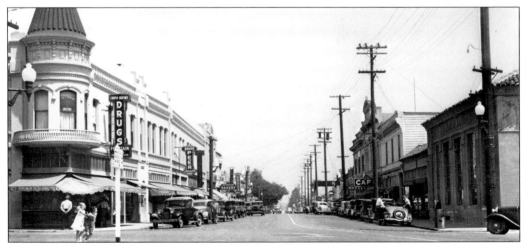

THE ELBOW. The heart of downtown, Santa Cruz Avenue and Main Street, is seen here *c.* 1935. (Courtesy of the Museums of Los Gatos.)

CONTENTS

ACKNOWLEDGMENTS

The wealth of Los Gatos historic primary source materials that have survived is enough to make any librarian glad. Many people helped me locate and weave those materials into this book.

Descendants of Los Gatos pioneer families generously shared photographs, letters, and essays from their private collections. My sincere thanks to Bruce Franks, who grew up in Los Gatos and on the family ranch just south of town, and who was part of the fire service in central California for more than 50 years. Three great-great-grandsons of early settlers provided invaluable materials. Frank Burrell had the oil portrayal of his ancestor Lyman Burrell restored in order for us to capture a clear image. He also loaned us letters written by Clarissa Wright Burrell dating from 1837. Stan Chinchen, whose ancestor is John Bean, lent photos and a detailed family history. David M. Shuman is descended from William C. Shore, whose picnic grounds were on the land where Highway 17 now runs. He worked with his mother, Elayne Shore Shuman, to gather family photos and news clippings that have been lovingly preserved. Barbara Gibson Baggerly lent me her scrapbook from the 1940 *Trail Days* pageant and celebration, and shared memories of her late husband John and his family. Bill Wulf, town historian extraordinaire, shared rare Los Gatos images from his lifetime collection and answered endless inquiries. I thank local historian Patricia A. Dunning for her discerning eye for detail and excellent counsel.

My fellow librarians were ever so generous in their collaboration. At San Jose Public Library, Bob Johnson helped me mine the rich resources of the California Room. Brian Fowler, my longtime colleague and dear friend, located lengthy contemporary news accounts of the 1883 hanging from the Main Street Bridge, information that had disappeared into the mists of time and lived only as uncertain rumor or legend. Rita Torres helped me with Spanish-language questions. Jean Nelson, a retired school librarian, helped locate descendants from the Bean family. Dr. Kevin Starr, State Librarian Emeritus and preeminent California historian, took time from his intensely busy schedule to write the introduction to this book, providing fascinating insights into the place of Los Gatos in California history.

Paul Kopach, our local history librarian, assisted me throughout this process, and the book would not exist without his efforts. I greatly appreciate Paul's dedication and hard work and that of our core of talented volunteers: Dudley Warner, Egon Jensen, Lyn Dougherty, Frank Gualtieri, Doris Keh, Dudley Warner, Io Berreitter, and Robby Morris. A heartfelt thank you to Los Gatos Library staff who helped with the project: Linda Dydo, Maureen Roll, Shirley Skellenger, Diane Otter, Judi Snyder, Sue Anderson, and Jan Robinson. Retired Captain Duino Giordano and Detective Sergeant Mike Barbieri of the Los Gatos–Monte Sereno Police Department shared photographs and memories. I thank Town Manager Debra Figone for her support and willingness to let me spread my wings. And special thanks to former mayor and current Councilwoman Sandy Decker. When Ruth Comfort Mitchell wrote "I yield to no one in my devotion to Los Gatos," she had not met Sandy, who would have been her match.

Laura Bajuk, delightful colleague and executive director of the Los Gatos Museum Association, is my partner in our efforts to preserve Los Gatos history. Library board members provided enthusiastic support: Karl Pearson, Rita Baum, Dale Hill, Kathy Cusick, and Kitty King. Dr. Robert Morris, representing IBM Corporation, and the members of the Los Gatos Lions Club donated funding and equipment. Many others helped to make this book possible: Sara Morabito and the History Club of Los Gatos, longtime Los Gatos antique dealer Shirley Henderson, Rob and Diana Jensen from Testarossa Vineyards, Dick Sparrer and Mary Ann Cook from the *Los Gatos Weekly Times*, Chris Miller and the Los Gatos Union School District, Bill Cilker and Beatrice Cilker Hubbard, Dr. Susan Shillinglaw at The Center for Steinbeck Studies, Charlene Duval of the Sourisseau Academy, and Marla Novo at the Museums of Art and History, Santa Cruz. And one last thank you to my friend Harry Farrell, longtime San Jose newsman and award-winning author, for advice and assistance.

INTRODUCTION

It can be argued that in terms of its site, its history, the colorful and talented people who have lived there, and the loyal feelings it has inspired for nearly 150 years, the Town of Los Gatos is among the most comprehensive, favored, and picturesque towns of its size in California. As the historic photographs and text in this elegant book attest, Los Gatos is no ordinary town. It is, rather, an almost complete statement about the possibilities of life in California.

Located at the base of the Santa Cruz Mountains, Los Gatos is from one point of view the southern edge of the San Francisco Bay Area. From another perspective, it is the gateway to Santa Cruz County. It is both of these things—and something more. It is a town enlivened by just about every topographical feature in California, with the exception of the desert.

First of all, Los Gatos is exquisitely situated on foothills, with views in many directions of the plain below and the even more ambitious mountains beyond. Few Italian hill towns can claim a more charming location. At Los Gatos, the urbanism of the San Francisco Bay Area, cresting in the great city of San Jose, the third largest city in the state, yields to the less settled foothills and, beyond these, to the groves of ancient redwoods of the Santa Cruz region. Thus at Los Gatos urbanism meets wilderness, mountain meets plain, foothills extend in every direction; and in the air, at various times and seasons, there is also the suggestion of the sea in the healing fogs coming over from the coast. If all this were not enough, Los Gatos even has its own creek, where in Native American times, Spanish and Mexican times, and through mid-20th century American times, the water flowed freely, rich in speckled trout for the taking.

In terms of the extended pageant of California history, Los Gatos has participated in each and every phase of California's development without losing the intimacy, the identity, of a foothill town. In terms of its post-Native American designation, Los Gatos begins as a Mexican land grant, the Rancho Rinconada de Los Gatos. During the Native American, Spanish, Mexican, and early American years, grizzly bears, mountain lions, and bobcats roamed the foothills—mountain lions especially, for which the town was named. During the 1850s, Los Gatos emerged as a way station between Santa Cruz and San Jose, served by picturesque Concord coaches. Alma, Lexington, and Wright's Station, all three little towns now gone, functioned along with Los Gatos as the harvesting and distribution centers for much of the lumber that went into the building of San Francisco and the New Almaden Quicksilver Mines.

During the first American decades, Los Gatos developed as an agricultural and transportation center, a shipping and market town, connected by rail to Santa Cruz and the Bay Area, on which the abundant harvests of the region—the great prune crops especially, but also apricots and other fruits—could reach their markets. In spring, the entire region from Los Gatos to Mount Hamilton was awash in white blossoms, truly earning the designation of the Santa Clara Valley as "The Valley of Heart's Delight." One Los Gatos orchardist, almond-grower John Bean, invented an innovative spray pump for insecticides. In time, the company formed by Bean and his son-in-law David C. Crummey, the Bean Spray Pump Company, developed into the Food Machinery Company, more commonly known as FMC, thereby including Los Gatos in the early annals of corporate America.

Civic life, social and communal, came early to Los Gatos—musterings of the Grand Army of

the Republic, gatherings of the Modern Workmen of the World, rallies by the Los Gatos Women's Christian Temperance Union—because the people of Los Gatos knew themselves as a community. The California-born philosopher Josiah Royce described such local patriotism as the golden age of High Provincialism in the state—the time, that is, starting in the 1870s, when Californians began to concentrate upon the development and enhancement of local civic ties. Los Gatos supported service clubs and cultural organizations even as a village. The Los Gatos Pageants, great outdoor spectacles that ran most years from 1919 through 1947, and engaged up to 500 members of the town in each production, illustrated the importance of building the cultural and esthetic side of the community.

Wisely, the Jesuit Order selected Los Gatos as the site of its Sacred Heart Novitiate, erecting its buildings just above the town. For more than 80 years, young men began their preparation for the Jesuit priesthood in these great stone buildings on sunny slopes. The Jesuits carefully cultivated their vineyards, and by the early 1900s the Novitiate Winery was the largest bonded ecclesiastical winery of its kind in the nation, serving the altars of Roman Catholic America, and giving—incidentally—young novices a chance to test their vocation during long sojourns in the field during the harvest season. The Sacred Heart Novitiate functions, in effect, like the Franciscan missions function for other California communities: as a way of suggesting California as the Mediterranean shores of Europe and recalling the significantly ecclesiastical origins of the Golden State.

As so many photographs in this book document, the aestheticism of Los Gatos and its surroundings has over the years made it a favored region of residence for artistic and literary people. In the 1890s essayist and poet Ambrose Bierce, who suffered from asthma, favored Los Gatos for its salubrious climate. In 1919 poet Sara Bard Field and her consort Colonel Charles Erskine Scott Wood settled in the nearby hills, commissioning from sculptor Robert Trent Paine the two great cats at the entrance to their estate, which to this day serve as the primary urban icons of the region.

Field and Wood were congenial people. They loved to entertain. And so did James Duval Phelan, the former mayor of San Francisco, living close by in a lavish estate called Montalvo. Down through the decades a journey to either Los Gatos or Montalvo became part of the protocol for visiting celebrities, especially if they were of a literary bent. Ironically, both John Steinbeck, who wrote *The Grapes of Wrath* nearby, and novelist Ruth Comfort Mitchell, who wrote *Of Human Kindness* to counteract Steinbeck's depiction of California as a hard-hearted place, were part of the Los Gatos scene, especially Ruth Comfort Mitchell, who made her permanent home here, as did the talented Menuhin family. Violin phenomenon Yehudi Menuhin grew up in Los Gatos and as an adult returned whenever possible to his beloved estate east of Lexington. Actress Olivia de Havilland graduated from Los Gatos High School in 1934. Five years later, she had a starring role in *Gone With the Wind*. Even the rogues of Los Gatos seemed to have a certain panache, if one is to judge from Los Gatos native Harold Homer Chase, alleged to have fixed the World Series in 1919.

So then—from Native American times to the present, from the days of Don Jose Hernandez and Don Sebastian Peralta to such current residents as Steve Wozniak, Peggy Fleming, and Thomas Kinkade—the region and, later, the town of Los Gatos have continued to cast a spell. It does so because of the beauty of the area, most obviously, and its civility, but also because down through the decades men and women have found in Los Gatos that blend of nature and civilization, the pastoral and the civic, that has always remained a continuing goal of Californians. Perceived as nature, Los Gatos is a favored place. Perceived as history, Los Gatos can tell itself a virtually complete California story. Perceived as a community, a place in time, Los Gatos remains an ongoing quest. This book represents a significant step on that journey.

—Kevin Starr, State Librarian Emeritus

One

OUT WEST

*We are the pioneers of the world; the advance –guard, sent on through the wilderness
of untried things, to break a new path in the New World that is ours.*
—Herman Melville

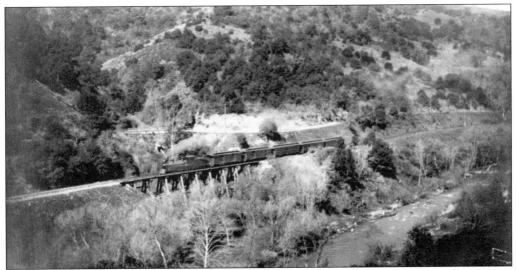

IN THE CORNER OF THE CATS. Unearthly screams of mountain lions by moonlight, horses galloping and neighing, whips cracking, oxen pulling wood in groaning wagons, grunts, curses, oaths, greetings, farewells, coaches rumbling and creaking, chuff of steam engines, lonesome whistles, clatter of rails, rush of water over stone—these were the sounds of Cats' Canyon, pictured here in the 1890s. A South Pacific Coast Railroad narrow-gauge train is heading south out of Los Gatos, on its way to Santa Cruz and the Pacific Ocean, 22 miles away. The old unpaved road to Santa Cruz is on the left, and the Los Gatos Creek is on the right. (Courtesy of William A. Wulf.)

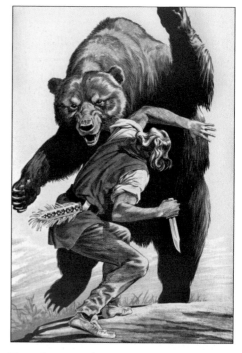

FELIS CONCOLOR. The imposing mountain range between Los Gatos and Santa Cruz has always been prime mountain lion country. Wild, solitary, and strongly territorial, mountain lions require isolated and game-rich wilderness. Six people have been killed by mountain lions in California since 1890. However sightings of the big cats are fairly common and have increased in recent years as humans crowd into the state's wildlands.

URSUS ARCTOS HORRIBLITS. Grizzly bears were common in the Santa Cruz Mountains until the middle of the 19th century, but disappeared before 1900. Hunting the bears was done both for sport and to eliminate the danger they posed. A grizzly can grow to massive dimensions, weighing between 300 and 850 pounds and standing 7 to 9 feet tall on powerful rear legs, as shown in this 1958 illustration by Lee Ames, from the book *Hoofs, Claws and Antlers: The Story of American Big Game Animals.*

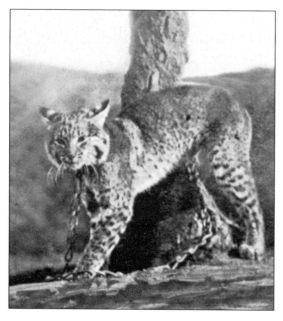

FELIS RUFUS. This popular Los Gatos postcard of a captive Bobcat was published *c.* 1900. Deer, coyote, foxes, and many types of smaller game also populated the landscape. They shared local terrain with the Ohlone Indians, the Spanish explorers who first arrived in 1769, the Franciscan missionary padres who arrived in 1777, and the Californios, Spanish-speaking people who settled on ranchos offered free to Mexican citizens willing to apply for them. Opportunities for wealth and prosperity would soon bring Yankee homesteaders, and at the end of the Mexican War (1846–1848), California belonged to the United States.

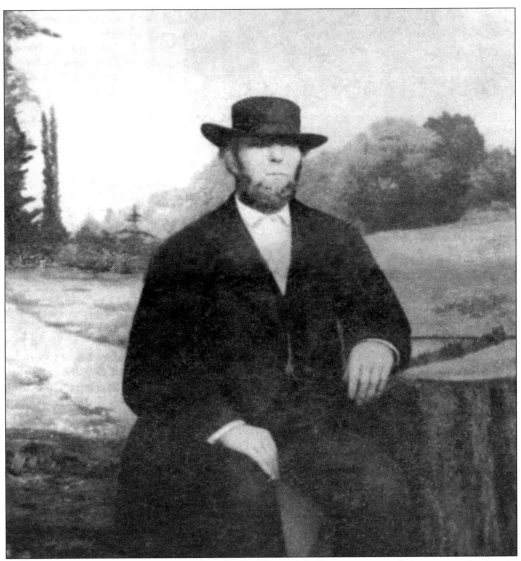

MOUNTAIN CHARLEY (1830–1892). Charles Henry McKiernan escaped the potato famine in his native Ireland and traveled to California hoping to find his fortune in the gold strike. In 1851 he settled at the summit of the Santa Cruz Mountains, the first permanent white settler in the area. While building his cabin he lived in the burned-out trunk of a redwood tree. On his homestead he raised sheep and cattle and planted orchards and vineyards. One night mountain lions killed more than 70 of his sheep. During a hunting expedition in May, 1854, McKiernan and a friend named John Taylor came face to face with a grizzly bear and her two cubs. She reared up on her hind legs, towering over the two men. Both men fired their guns, but the bear seized McKiernan with her front paws and crushed the area over his left eye with her powerful jaws. Taylor managed to escape, but McKiernan was left with a severe wound, which a San Jose doctor treated by fashioning a plate of silver to cover the area of crushed bone. The plate was probably made from Mexican pesos and soon had to be removed because of infection. Although disfigured (he wore a hat low over his "bad lamp" for the rest of his life), he regained his health. He died in January 1892, 38 years after the bear fight that made him famous. (Courtesy of the Museums of Los Gatos.)

MRS. CHARLES McKIERNAN. Barbara Berricke Kelly was also an Irish immigrant and a nurse. She and Charles married in 1862 and raised seven children on their summit ranch, which included more than 3,000 acres of redwood forest. Their property also incorporated orchards, vineyards, and saw mills, and was a stagecoach stop where tolls were collected for use of the mountain road through their land. The McKiernans lost a nine-year-old son in a shooting accident when the gun the child was playing with at home went off accidentally. (Courtesy of the Museums of Los Gatos.)

KATHRYN, MOLLY, AND HELEN. Charles and Barbara McKiernan's three daughters formed a lovely trio. The family eventually moved to San Jose in order that the children would have better access to schools. (Courtesy of the Museums of Los Gatos.)

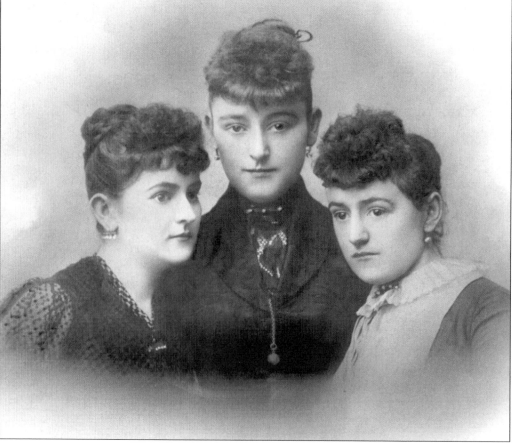

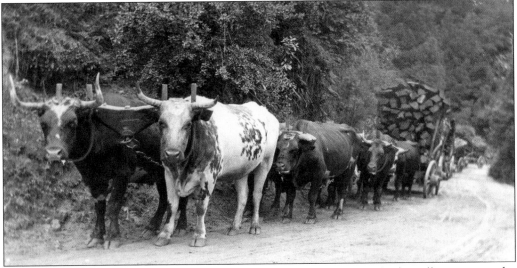

FOUR-SPAN OF OXEN. Coastal Redwood trees (*Sequoia Sempervirens*), the tallest trees in the world, covered the Santa Cruz Mountains until they were heavily cut in the 19th century. Many stands of ancient redwoods were harvested with seemingly small regard for their beauty or for conservation of the natural environment. Thousands of board feet of lumber were transported through Los Gatos for distribution along the Pacific Coast, including San Francisco, and to the quicksilver mines at New Almaden. After gold, redwood was the next treasure for fortune-seekers, and in the 1860s about a dozen sawmills existed in the area. Oak, pine, spruce, manzanita, sage, and chaparral also grew densely in the mountains. (Courtesy of the Museums of Los Gatos.)

SHOEING AN OX. Heavily laden flatbed lumber wagons pulled by horses or oxen and driven by teamsters could go out of control and skid over cliffs to the deep ravines below. The plodding oxen wore bells, to warn stage coaches careening toward them from the opposite direction. The oxen were shod to protect their hooves on the rough roads, and so the blacksmith was critical to the success of lumbering. He forged the shoes and the nails and charged for both. (Courtesy of the Sourisseau Academy.)

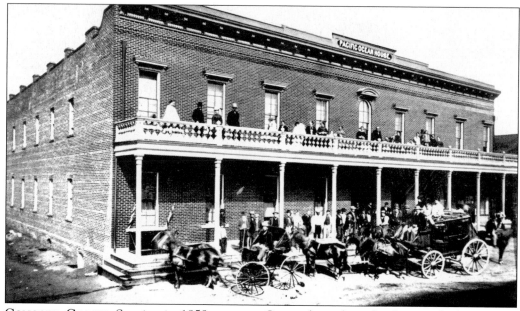

CONCORD COACH. Starting in 1858, one-ton Concord coaches, the finest vehicles of their time, were pulled over the mountains to Scott's Valley by six-horse teams. From there, a four-horse team would pull the coach into Santa Cruz. Thundering down the roads, the horses would arrive at stage stations snorting and prancing. This 1866 photograph shows a coach that has just traveled over the mountains from Los Gatos to the Pacific Ocean House in Santa Cruz. Trips by stage over the mountains were not for the timid. Danger and discomfort were to be expected. Published hints for travelers included the following: bathe your feet before starting, don't smoke a strong pipe inside the coach, always spit on the leeward side, and if you have anything to take in a bottle, pass it around, for a man who drinks by himself in such a case is lost to all human feelings. (Courtesy of William A. Wolf.)

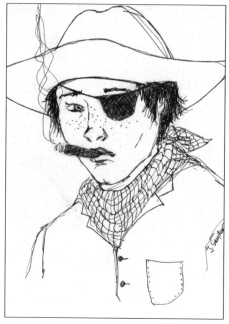

CHARLEY PARKHURST (1812–1879). One of the most renowned stagecoach drivers in the area was "One-Eyed Charley." Charley smoked cigars, swore, drank in moderation, "chawed terbaccy," and had a raspy voice and a sharp whistle, which was used to warn that a stage was coming around the bend. An experienced "whip," Charley could drive six-ups (six horses) with ease, despite being small in stature and wearing a patch over one eye. Dressed in a buffalo skin coat and cap, Charley faced winter storms and runaway teams in an era when headlines like "Hogs Frighten Horses, Stage Plunges Into Gulch" were common. A legend was born when, at death, Charley was discovered to be a woman whose given name was Charlotte. She registered to vote in Santa Cruz County in 1867, 53 years before women were allowed to vote in federal elections in the United States. She registered as "Charley Darkey Parkhurst," age 55, occupation farmer, native of New Hampshire. (Original art courtesy of Judi Synder.)

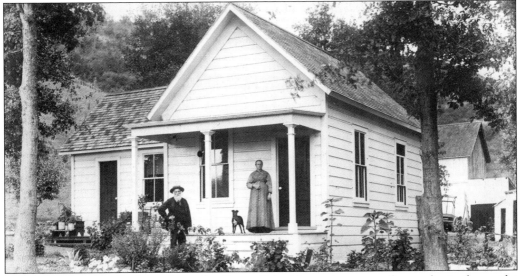

THE TOLL HOUSE. Early roads in the Santa Cruz Mountains were often only six feet wide, ungraded dirt paths, or "skid rows" made for harvesting logs. They were treacherous, rutted, steep, and in winter turned to mud. Zachariah "Buffalo" Jones, an early settler, turned the steep trail over his property, about where the Novitiate was later built, into a toll road, and he collected money from stage coaches and lumber wagons. The Santa Cruz Gap Turnpike Joint Stock Company was a private enterprise chartered on November 17, 1857, to construct a toll road to the summit. James Kennedy, pictured here with his wife, Serena, built the toll house in 1867. It also served as their home. The company's charter expired on November 17, 1877, and two days later, angry teamsters pulled the gate to the creek and dumped it in. It was rebuilt and once again landed in the water. These incidents were dramatized in the *Trail Days* pageant of 1940. The road was declared public in 1878.

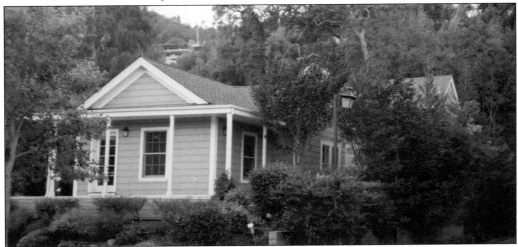

LOS GATOS LANDMARK. Joseph Johnson and Peter Davidson paid the first toll on May 5, 1858. After 137 years, the little toll house still stands guard, but collects no tolls, at the entrance to Cats' Canyon. The building has undergone much reconstruction through the years and was even disassembled and then restored in 1994. Now a part of the Toll House Hotel complex, thousands of vehicles pass by each day, replacements for the stagecoaches and wagons, mounted riders, foot travelers, and pack trains.

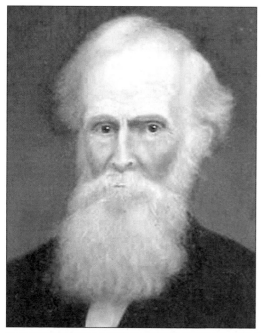

LYMAN J. BURRELL (1801–1884). Lyman J. Burrell was born in Sheffield, Massachusetts, and is pictured here at age 77. He moved with his family to the "vast wilderness" of Ohio, became a farmer, and married Clarissa Wright in 1839. But he called himself a "natural pioneer" and traveled to California for gold in 1849. In 1853, the Burrells settled in their Mountain Home at the summit of the Santa Cruz Mountains, a few miles from the McKiernan's. Four yoke of oxen and two wagons pulled the family's household goods up the mountain, including iron bedsteads from Boston and "one little pig in a box." The journey took three days. They traveled over logging roads and areas with no roads at all. Clarissa Burrell was in frail health, but complained only that the new place "is not handy to market." Lyman wrote "I knew that bears and lions dwelt here, but I feared them not." (Courtesy of Frank Burrell.)

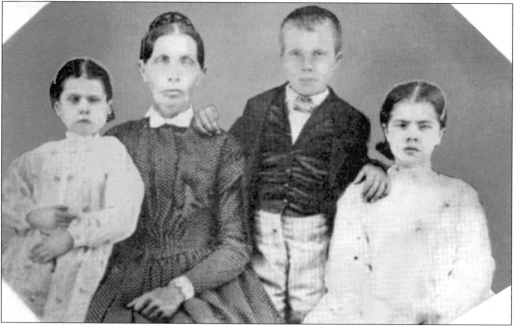

LETTERS FROM CLARISSA. Lyman and Clarissa Burrell (1805–1857) had three children. Despite the challenging life she led as a pioneer, Clarissa managed to write a series of letters, in a fine Victorian hand, which now serves as a valuable primary source of information about the period. She tells of her 103-day trip to California around Cape Horn with her children, of life on the mountain top, and of her husband's encounter with a grizzly bear. When she died she was buried on the mountain ranch. Her son James Birney Burrell (1840–1921), pictured here with his mother and sisters Clara (left) and Martha (right), was one of Santa Clara Valley's pioneer fruit growers. (Courtesy of Frank Burrell.)

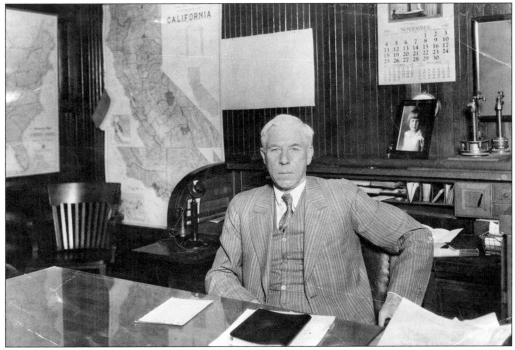

PIONEER LEGACY. The three earliest settlers in the Santa Cruz Mountains, Charles McKiernan, John Martin Schultheis, and Lyman Burrell, were the forerunners of the mountain orchardists, basic to the economy of the region. Fruit trees grew with ease and produced abundantly. Lyman Burrell planted his fruit trees as early as 1856. Many descendants of the pioneer families stayed in the Santa Clara Valley and prospered. Frank L. Burrell, Lyman's grandson, was born in Los Gatos in 1873 and spent his youth working in the orchards of the Burrell ranch. With his father, James Birney Burrell, he built a machine that picked prunes mechanically and graded them for size. The company built by Frank L. Burrell was merged with other companies to form the present day FMC Corporation, where he is pictured as manager in 1928. (Courtesy of Frank Burrell.)

HUNTING COMPANIONS, 1885. Dr. R.P. Gober (1859–1943), pictured second from left, came to Los Gatos in 1884 and served as a "horse-and-buggy" doctor. He answered sick calls throughout the mountains, delivering babies and even performing emergency operations in lonely cabins, taking a door from its hinges to use as a surgery table. More than once he was swept from his carriage while braving swollen winter streams to get to his patients. Dr. Gober was one of the 100 petitioners who sought to incorporate the town of Los Gatos in 1887, and he served as the Southern Pacific Railroad physician in Los Gatos for half a century. Dr. Gober was also president of the Mountain Spring Water Company, a member of the first board of health, a member of the Citizen's Committee for the Carnegie Library, and the son-in-law of John Bean. This group of friends is pictured in the Santa Cruz Mountains, possibly at the site of an abandoned logger's cabin. (Courtesy of the Museums of Los Gatos.)

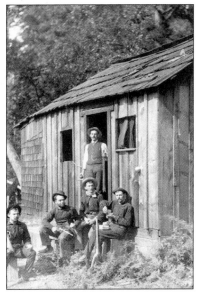

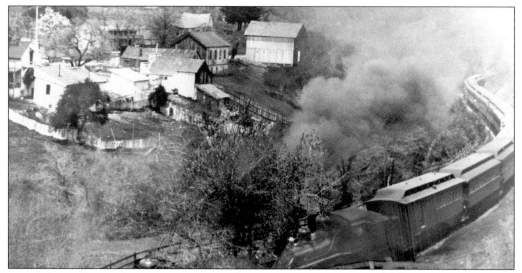

LEXINGTON. Situated about three miles above Forbes Mill, and originally called Jones' Mill, Lexington sat on a grassy flat surrounded by virgin redwoods. The first sawmill appeared in 1847, and by 1867 Lexington had become an active center of commerce, with eight sawmills listed in the *Pacific Coast Business Directory* of that year. It had a hotel, a livery and blacksmith shop, and J.W. Lyndon sold lumber and groceries. Prominent families included the McMurtrys and McMillans. At one time the population reached 200, considerably larger than Los Gatos, which at the time served as a whiskey stop for lumbermen going from San Jose into the Santa Cruz Mountains and back out again. Lexington was the half-way stop for stagecoaches running between San Jose and Santa Cruz. But as the local lumber was depleted, the saw mills moved deeper into the mountains and the town declined. This photo shows a Southern Pacific train passing Lexington in 1909. (Courtesy of William A. Wulf.)

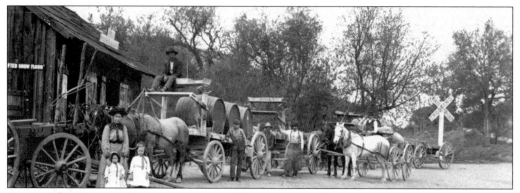

ALMA. The town of Alma, founded in 1877, was located about a mile south of Lexington. Originally called Forest House, Alma was a bustling stagecoach stop and later a South Pacific Coast Railroad stop. In 1873, the post office was moved from Lexington to Forest House after a flood of complaints from mountain people who did not like passing through the saloon in Lexington to reach the post office at the rear of the building. In 1904, the *San Francisco Chronicle* described Alma as a pastoral, mountainous amphitheater. "Peace broods over the fruitful orchards and heavy-laden vineyards, and sings in every ripple of the mountain born stream that dances down the canyon." Near the center of town was George Osmer's General Store, pictured here about 1900 with his daughter Marian Osmer Davies and children. (Courtesy of Bruce Franks.)

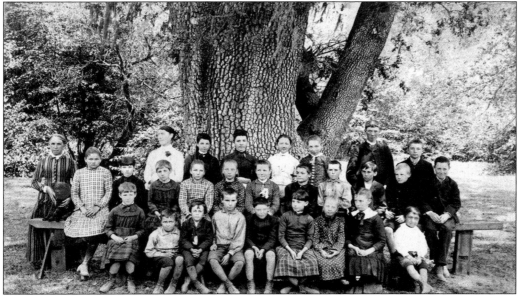

CLASSMATES. The students of Lexington School in Alma gather around a giant oak tree for a photograph, *c.* 1890. High-button shoes were in vogue. The adult woman on the far left, perhaps the teacher, is holding onto a small black dog. (Courtesy of Bruce Franks.)

THE OLDEST SCHOOL. Founded in 1859, Lexington School in Alma was the first to be established in the area. John Pennell Henning, owner of two lumber mills in the redwoods near Lexington, donated the lumber for the school and for a temperance hall that was built near Alma. A second room was added to the school in 1928, after the building had been moved to a different location. In 1953, Lexington School opened its doors on its present five-acre site above the Alma Fire Station. (Courtesy of Bruce Franks.)

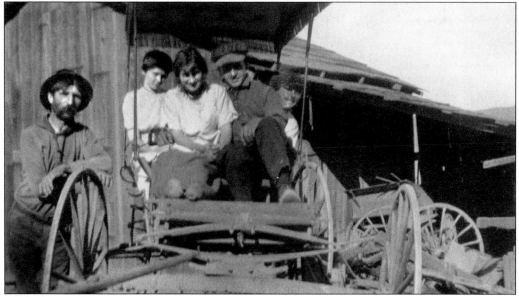

FARM SCENE, NEAR ALMA. Early travelers from Los Gatos to Alma described the route as "the Switzerland of America," with pure air, dramatic rock formations, and the trout-filled Los Gatos Creek. Alma became a destination, with people coming for the medicinal effects of the local soda springs. By 1887 Alma was thriving, and soon local loggers had their choice of 12 saloons that lined the one-mile route between Lexington and Alma. In the 1920s automobiles began to arrive in Alma, filled with tourists on their way to the ocean at Santa Cruz. And yet this remained an agricultural area, with abundant production of prunes and grapes. The prunes would be loaded in wagons for a trip down to the Hunt Brothers Cannery, which was located on the current site of Highway 9 and North Santa Cruz Avenue. (Courtesy of Bruce Franks.)

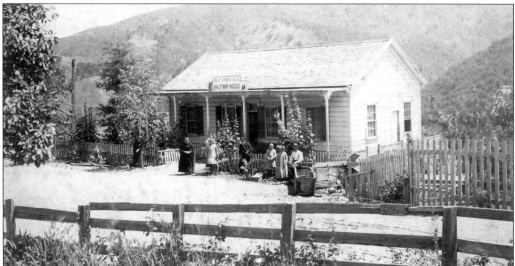

HALFWAY HOUSE. Information on the back of this *c.* 1880 photograph indicates the "Halfway House" was a saloon belonging to Fred Riecke and located at the corner of Old Santa Cruz Highway and Idylwild Road, a few miles "above" Los Gatos. In 1887, Los Gatos incorporated and went "dry," thus affording no competition for the saloons in the foothills. (Photo by C.E.F. Wyttenbach, San Francisco; courtesy of the Museums of Los Gatos.)

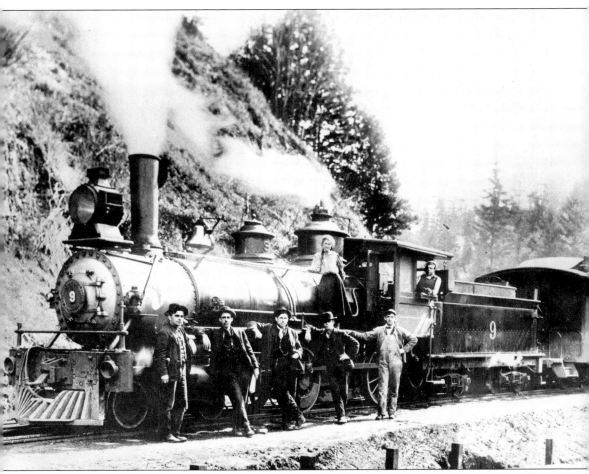

THE RAILROAD. In the post–Civil War 1870s, a trip over the Santa Cruz Mountains was still a rugged and perilous adventure. The *San Jose Mercury News*, July 7, 1877, reported, "A horse and buggy trip over the Santa Cruz Mountains from San Jose to Santa Cruz was made in four hours. Roads were so bad and speed so rapid that the horse died shortly after the completion of the trip." On March 20, 1878, the South Pacific Coast Railroad arrived in Los Gatos, coming from Alameda through San Jose. Two years later, in the spring of 1880, the monumental task of building the railroad over the Santa Cruz Mountains had been accomplished. More than 60 men were killed during construction, many in tunnel explosions. This photo shows the South Pacific Coast Railroad Number 9 at Wright's Station during the winter mudslides of 1893. Alice Matty is the young woman standing on the engine. She was the first woman station agent hired by the Southern Pacific in California and was also the telegrapher and ticket agent at Wright's. In later years she worked at the Bank of America in Los Gatos when it was located at Main Street and North Santa Cruz Avenue. Costing $110,000 per mile in the mountains, the SPCRR was the most expensive narrow gauge of the era to build. By this time, the mountains were covered with small farms and orchards, and the local farmers found the railroad a convenient way to ship produce to market. In 1886 the line was acquired by the Southern Pacific Railroad. Always difficult to maintain, railroad service through the mountains was discontinued due to storm damage in 1940. (Courtesy of William A. Wulf.)

CHINESE LABOR. The railroad was primarily constructed by Chinese laborers, numbering anywhere from 600 to several thousand. The road was blasted up into Wildcat Canyon, following the course of the Los Gatos Creek, with stops at existing lumber mills. In places the hills were so steep that workmen had to be lowered into the creek bed in baskets to carve out the roadbed. The tracks were forced to cross and re-cross the creek many times before reaching the summit. Total construction costs ran to $12 million. This rare *c.* 1885 photograph shows the wooden facer of Wright's Tunnel at the left. During periods of railroad construction, Los Gatos had a China Camp along the west bank of Los Gatos Creek. The camp consisted of shanties which housed hundreds of Chinese. Anti-Chinese sentiment was strong in the town. (Courtesy of William A. Wulf.)

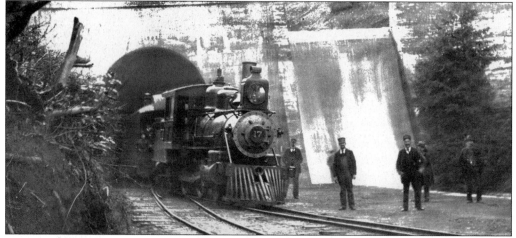

TUNNEL AT WRIGHT'S STATION. When railroad laborers arrived to begin work at the site of Wright's in 1877, it was occupied by one tumble-down shack. Bunkhouses, a cookhouse, and tool sheds sprang up to accommodate the crews who dug a tunnel more than a mile long through the mountains. The most notorious Wright's establishment was a saloon named "The Tunnel." Owner O.B. Castle served his "Famous Discovery," consisting of one gallon of "mountain dew" with four tablespoons of water, downed at one sitting. The *San Jose Mercury Herald* reported that Wright's was "wide open and wooly as many better known strongholds of western lawlessness." To protect the entrance of the tunnel from mudslides, a concrete portal and spillway were in place by 1893. (Courtesy of the Museums of Los Gatos.)

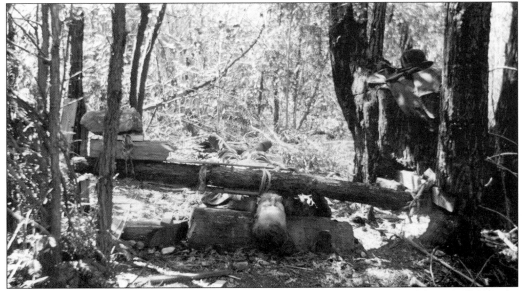

FRENCH WOODCUTTER'S GUILLOTINE. Testimony to the ruggedness and loneliness of life in the 1880s near Wright's is graphically captured in the suicide of a French woodsman, who fashioned a home-made guillotine to end his own life. The "sidechopper-style" guillotine had a rope that he pulled while laying face up on a log chopping block. The blade did not sever his head, but cut his throat enough to cause death. This photo, from the Clarence Hamsher collection, has hung in Los Gatos Library for more than 50 years without identification of the man involved.

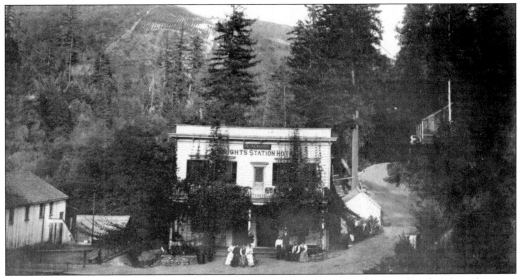

WRIGHT'S STATION HOTEL. The area around Wright's Station eventually developed into a town, named for the Reverend James Richard Wright, a retired Presbyterian minister from Michigan, and brother of Clarissa Burrell. This c. 1901 photo shows stately redwoods, along with vineyards and orchards on the hills in the background. From the 1880s until 1906, thousands took trains to picnic at Sunset Park, built by the Southern Pacific Railroad to promote weekend traffic. There was no lack of alcohol in the park, and it wasn't unusual for the crew of returning trains to toss the most unruly drunks off at Los Gatos. When the automobile came on the scene, visitors often traveled to more distant resorts, bypassing Wright's.

PIONEER FAMILY. Christian and Marie Frank, with their daughter Estella, are pictured *c.* 1890 on their ranch of 60 acres, which included parts of the current Chemeketa Park residential area. Christian was a sea captain from Germany who came to the Pacific Coast on a lumber schooner. When he purchased the land, it was planted with grapes. A root disease killed most of the plants, and they were replaced with French prunes. (Courtesy of Bruce Franks.)

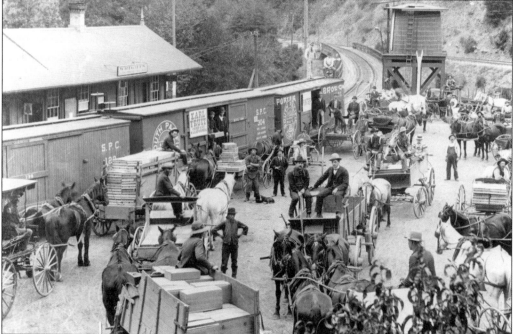

FRUIT OF THE MOUNTAINS. This *c.* 1893 photo shows farmers delivering their fruit by horse and wagon to Wright's Station for shipment to canneries in the Santa Clara Valley. Once canned, fruit was sent on to the East Coast and to England. Traveling by train to New York, it was then loaded on White Star Line steamers for the journey to Liverpool and on to London. About 3,200 acres of bearing trees and vines were in the Wright's vicinity. The Earl Fruit Company operated in Wright's at the turn of the 20th century as an agent for the canneries.

AUSTRIAN GULCH AND GERMANTOWN. Across Los Gatos Creek from Wright's Station, Austrian and German refugees from the Franco-Prussian war of 1870–1871 established a colony. Vineyards were planted and a community winery built in the center of the 1,000 acre settlement. One day in 1896 they dressed in their "Sunday best" for photographs. By 1934, all evidence of the villages had disappeared. (Courtesy of the Museums of Los Gatos.)

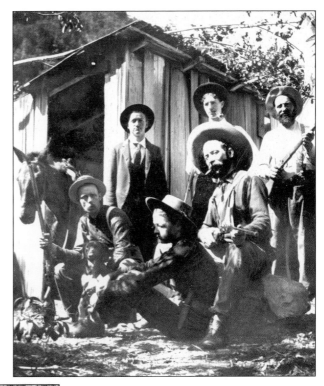

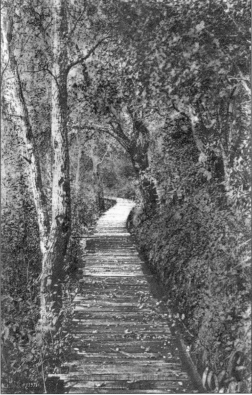

LOVERS' LANE—THE OLD WOODEN FLUME. Since November 1, 1866, when it was founded, San Jose Water Company has been closely identified with Los Gatos. In 1870, the company purchased water rights on the Los Gatos Creek from the Los Gatos Manufacturing Company and began to develop a water supply from the creek. In 1871, a wooden flume was built along the east bank of Cats' Canyon in order to pick up water at Jones Dam above Alma and bring it to Los Gatos. This 1907 postcard shows a portion of the 1880 reconstructed flume dubbed "Lovers' Lane." While "flume walking" was not part of the design of this apparatus, it was a popular activity, and continued even when the water company hired an inspector to prevent the practice. Encounters with wild cats and skunks would have made it less romantic. The three-mile long flume was replaced by a galvanized aqueduct in the 1930s.

HOLY CITY. In 1918, William E. Riker (1873–1969) purchased acreage in the Santa Cruz Mountains to build Holy City on the old two-lane Los Gatos–Santa Cruz Highway, about ten miles south of Los Gatos. The utopia he envisioned was financed by using the life savings of his followers. A bigamist, a zealot who believed in white supremacy, an electrifying and hypnotic preacher, and a four-time candidate for governor, Father Riker and his followers lived at Holy City and were members of "The Perfect Christian Divine Way." Up to 300 disciples were provided with food and housing, but all earnings and resources were turned over to the PCDW. Men and women were strictly segregated in the commune, and marriage was forbidden, although "Mother Lucille," Riker's third wife, ruled as "Queen" at Holy City for 31 years. Tourists found Holy City a fascinating, colorful, garish place to stop on the mountain road, a chance to hand-pump gas into the automobile, purchase a cornucopia (ice cream cone), visit the monkeys in the zoo, and pay 10¢ to look at the moon through a telescope. Tall biblical messages were posted around the property. Reiker claimed to have the "true solution" for polio, smog, cancer, and stroke. In 1929 he founded radio station KFQU in order to spread his message. The opening of the new four-lane mountain highway (1938–1940) was the beginning of the end for Holy City, as tourists bypassed the settlement on their way to the beaches of Santa Cruz. Riker sold Holy City for $64,000 in 1957, and he died at Agnews hospital in 1969 at the age of 96, after converting to Catholicism. Most of the buildings were later burned by arsonists. (Courtesy of William A. Wulf.)

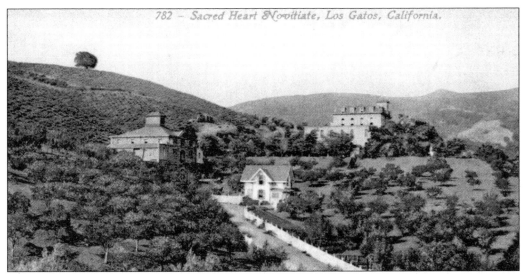

SACRED HEART NOVITIATE. In 1886, the Jesuit Order purchased the Harvey Wilcox ranch with flourishing orchards and vineyards overlooking Los Gatos. The Novitiate formally opened on July 25, 1888, and since that time has stood majestically on the hills immediately south of Los Gatos, "at the top of College Avenue." Young men entered the Novitiate to undergo the 13 years of training required to become a Jesuit priest. During the 1950s, former California Governor Jerry Brown studied for the priesthood at this location. Renamed the Jesuit Center in 1968, these buildings now serve as housing for retired priests.

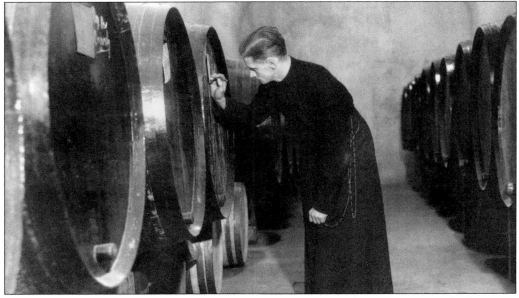

"HEAVENLY WINE, DEVILISHLY GOOD." Novitiate wine production began with the grape harvest of October 11, 1888. For many years the Novitiate Winery was the largest bonded ecclesiastical winery in the country. This photo, dated April 24, 1934, shows Brother Oliver J. Goulet (1905–1962) in the subterranean wine cellars, recording technical data on one of hundreds of casks of wine. Brother Goulet served as winemaker from 1931 to 1936. The winery closed in 1985, but during its last 20 years commercial sales had increased. Testarossa Vineyards now produces wine at this location.

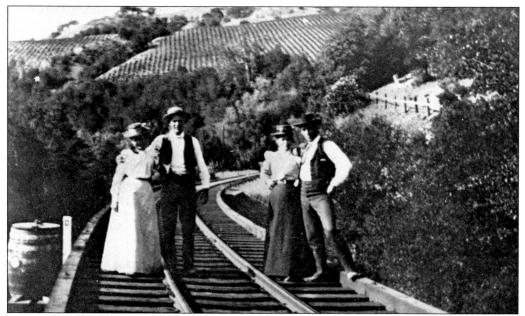

WALKING THE RAILS. A stroll from Los Gatos to Alma or Lexington could easily be accomplished by walking the rails, with less chance of foxtails and poison oak. This photograph is looking north toward the vineyards of the Sacred Heart Novitiate. On January 23, 1926, this popular practice resulted in a predictable tragedy. Helen Dossee, age 11, and her sister Jane, age 9, were trapped on the trestle just south of town when the 3 p.m. passenger train from Santa Cruz bore down on them. To escape, they jumped 60 feet to the rocky creek bed below. Helen died, but Jane survived. The sad news was taken to their mother, Zoie Dossee, who worked as a saleswoman at Crider's Department Store. The girls had been out hunting berries. (Courtesy of William A. Wulf.)

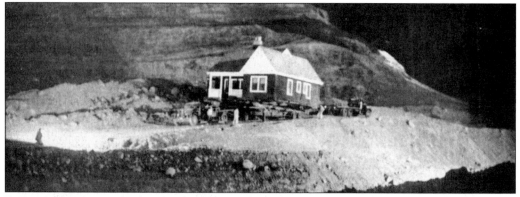

LADY IN THE ATTIC. A dam was built across Los Gatos Creek in 1952 in order to capture water from mountain streams, which originally flowed all the way to San Francisco Bay. The resulting reservoir covered the historic towns of Alma and Lexington. Very little evidence is left of the many towns that thrived in the Santa Cruz Mountains in the days of lumber, fruit, and railroads. Damming of Los Gatos Creek was bitterly opposed by some, none more vehemently than the last woman to leave Lexington. She refused to vacate her home, even as it was condemned and moved from its perch on the top of the new earth-filled dam. This photo was taken at 2 a.m. by photographers Harry T. Richards and Carl B. Cunningham as the structure was brought out.

Two

EL RANCHO RINCONADA DE LOS GATOS

Adown Los Gatos' fairy vale a silver brooklet ran . . .
—A.J. Waterhouse

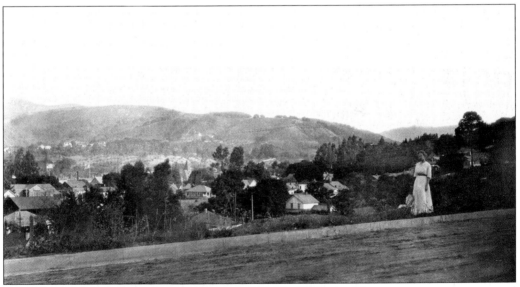

LOS GATOS, GEM OF THE FOOTHILLS. On July 23, 1839, the Mexican government granted 6,631 acres of land to brothers-in-law Jose Maria Hernandez and Sebastian Fabian Peralta, residents of the neighboring Pueblo de San Jose de Guadalupe. The grantees constructed their first adobe home on the banks of Los Gatos Creek, in what is now Vasona Park. Today the Town of Los Gatos is located within the original boundaries of the old rancho, nestled where the Santa Clara Valley meets the Santa Cruz Mountains. On a rainy day in 1907, Miss Argie Ross stands on Glen Ridge Avenue, overlooking the village.

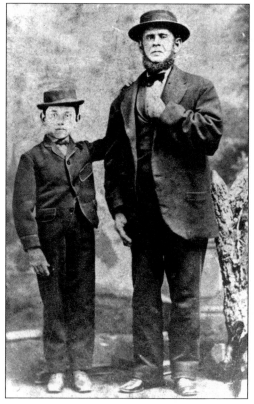

GRANTEE OF EL RANCHO RINCONADA DE LOS GATOS. Jose Hernandez poses with one of his 13 children, including nine sons, in the late 1850s or early 1860s. Just visible are the photographer's stands behind the two subjects, to assist them in standing still during the long exposure. The boy in the photo may be Francisco Hernandez, born in 1849. In the 1950s, Mrs. Fremont Older (1875–1968) interviewed several Hernandez descendants. Anita Hernandez Parks, daughter of Francisco Hernandez, said her father was always called "The Spanish Prince." Jose Hernandez reportedly lived to be 96 years old. (Courtesy of William A. Wulf.)

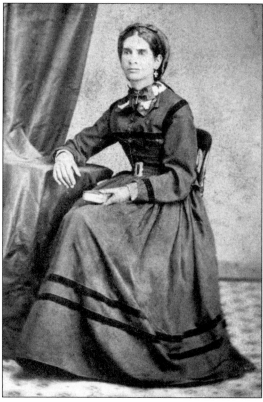

MARIA FRANCISCA HERNANDEZ DE WORDEN. Francisca was the first-born child of Jose Hernandez and his first wife, Maria Gertrudis Ines Hernandez. Little is known of Francisca, except that she was baptized on September 14, 1831, and that she married a man named Worden. In this early photograph she is shown holding her Bible. (Courtesy of William A. Wulf.)

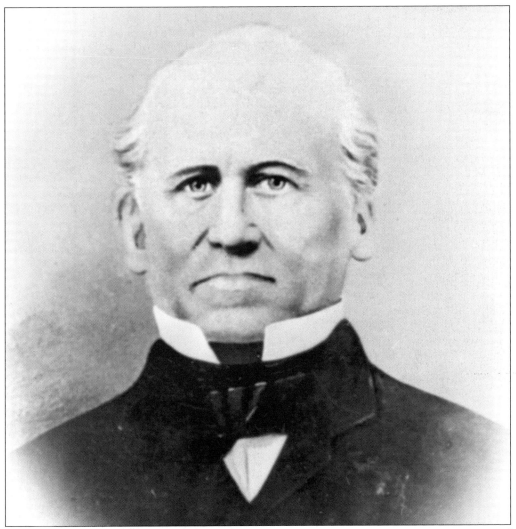

JAMES ALEXANDER FORBES (1805–1881). This pioneering entrepreneur, a native of Inverness, Scotland, was an early arrival in California, landing in 1831 at the little settlement of Yerba Buena, now the city of San Francisco. He was married on July 4, 1834, to Ana Maria Galindo, a native of Mission Santa Clara and daughter of Juan Crisostomo Galindo and Ana Jacoba Bernal Galindo. Forbes served as a vice counsel to the British Government in San Francisco, and in 1845 he became an agent of Hudson's Bay Company. In late 1852, he acquired 2,000 acres of the original Rancho Rinconada de Los Gatos from Jose Hernandez, with the idea of building a flour mill. Within two years, the four-story building stood on the banks of Los Gatos Creek, built of quarried stone with walls four feet thick. However, the milling equipment shipped from Rochester, New York, arrived after the building was complete and proved very difficult to install. On December 1, 1855, the mill finally started to grind the wheat of local farmers, but the operation did not prosper. On May 29, 1857, the Santa Rosa Brand Flour Mill and its surrounding land were sold in a sheriff's bankruptcy sale on the steps of the Santa Clara County court house. The failure of the mill was one of several misadventures that Forbes, who never lost his Scottish burr, suffered during his lifetime. However, his efforts were the beginning of Los Gatos, and the village slowly grew along East Main Street. James and Ana Maria Forbes had twelve children—nine sons and three daughters.

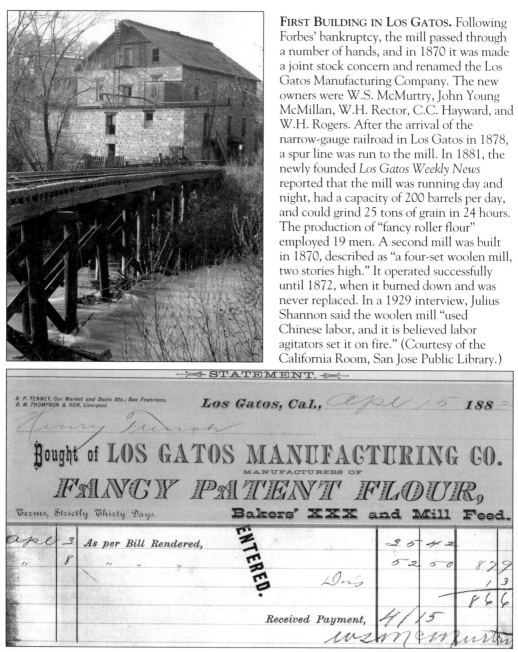

FIRST BUILDING IN LOS GATOS. Following Forbes' bankruptcy, the mill passed through a number of hands, and in 1870 it was made a joint stock concern and renamed the Los Gatos Manufacturing Company. The new owners were W.S. McMurtry, John Young McMillan, W.H. Rector, C.C. Hayward, and W.H. Rogers. After the arrival of the narrow-gauge railroad in Los Gatos in 1878, a spur line was run to the mill. In 1881, the newly founded *Los Gatos Weekly News* reported that the mill was running day and night, had a capacity of 200 barrels per day, and could grind 25 tons of grain in 24 hours. The production of "fancy roller flour" employed 19 men. A second mill was built in 1870, described as "a four-set woolen mill, two stories high." It operated successfully until 1872, when it burned down and was never replaced. In a 1929 interview, Julius Shannon said the woolen mill "used Chinese labor, and it is believed labor agitators set it on fire." (Courtesy of the California Room, San Jose Public Library.)

WILLIAM S. MCMURTRY. This receipt was signed in 1882 by W.S. McMurtry, M.D. (1818–1909), a native of Kentucky who practiced medicine in Mississippi until the outbreak of the U.S.–Mexican War (1846–1848), in which he served. After the war he came to California for gold, arriving in San Francisco on May 24, 1849, via sailing ship. He engaged in mining in the Grass Valley area and then relocated to Lexington in 1858, where he engaged in the lumber business. In 1868 he moved his family to Los Gatos. Dr. McMurtry was elected state senator for Santa Clara County in 1863 and served one term. In 1864 he traveled to the Republican convention in Baltimore to cast his vote for the nomination of Abraham Lincoln as president for a second term.

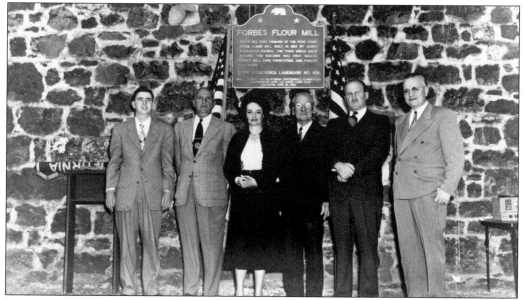

HISTORIC LANDMARK DEDICATION, JUNE 10, 1950. The flour mill prospered, producing fine flour into the 1880s. George S. McMurtry, town treasurer for 40 years and William S. McMurtry's son, recalled working at the mill in the 1880s when it was common to see a string of teams two or three blocks long, waiting at the doors of the mill to unload wheat. However, fruit orchards were replacing wheat fields, and the mill ceased flour production in 1887. The building was damaged in the 1906 earthquake, and demolition began in 1916, saving only the storage annex that had been added in 1880. That annex now houses the town's history museum. The California Centennial Commission designated the mill as State Historical Landmark number 458 in this 1950 ceremony. From left to right are William Abeloe, a leader in the landmark movement; Allan S. Vishoot Sr., president of the Los Gatos Lions Club; Lutheria Cunningham, great granddaughter of James Alexander Forbes; Joseph Knowland, chairman of the California Centennial Commission; Clyde Arbuckle, San Jose City Historian; and James F. Thompson, mayor of Los Gatos. (Courtesy of the Museums of Los Gatos.)

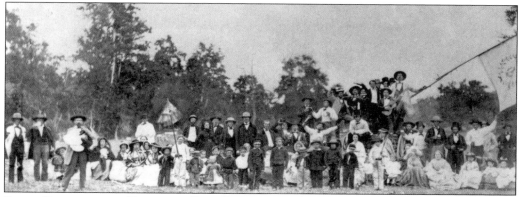

FIRST PHOTOGRAPH TAKEN IN LOS GATOS. A July 1866 issue of the *San Jose Mercury* mentions a popular picnic grounds "near the stone mill (formerly Forbes Mill), on the road to Lexington from San Jose." This 1861 daguerreotype of the San Jose German Glee Club's picnic was almost certainly taken at that site. During the 1860s, the town grew to include a blacksmith shop, a lumber yard, a few scattered homes and shanties, a store, a school, the First Methodist Church, and the Ten Mile House—a combination hotel, saloon, post office, and stage depot.

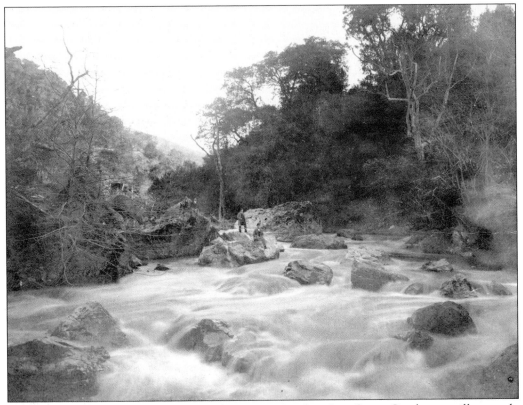

LOS GATOS CREEK. This photo was taken in 1899, when Los Gatos Creek was still a nearly year-round stream, before the waters were dammed. Los Gatans could walk to the northerly running through-town creek almost any month of the year and catch speckled trout for dinner. The fish were so plentiful it was said they could be caught by hand. The earliest mention of Los Gatos Creek in the press is probably an 1868 *San Jose Mercury* article, wherein the editor reported, "We saw at Fulton's fish market last Thursday a fish caught in the shallow water of the Los Gatos Creek, near town, which weighed $16^1/_2$ pounds. In shape its body resembled the common salmon, but the extremities of its jaws were armed with rows of dog-like fangs, hooked inward and sharp as needles, making it a most formidable and destructive fellow among its finny mates. It is called the dog salmon, and is very rare in our inland waters. It was killed with a shovel in the hands of a man who accidentally came across his fishship disporting in his native element." This photograph was taken just south of town, where the freeway now runs. The men are holding pistols.

JOHN WELDON LYNDON (1836–1912). Lyndon was only 10 years old when he left his parents' Vermont home to make his own living. He arrived in California in 1859 via the Isthmus of Panama. His first job was at Lexington, where he worked at H.M. Hervey's boarding house and learned to drive an ox team. Soon he owned his own Lexington general store, but in 1868 he sold the store and returned to Vermont. When he came back to Los Gatos later that year, along with his younger brother James Lyndon, just out of the Union Army, he purchased a 100-acre tract of land that included the old "Ten Mile House" and today would include most of the business district of the town. He married Theresa Rector of Oregon in 1872. She died in 1889, and in 1892 he married Marian Carson. A stockholder in the Los Gatos Fruit Packing Company and the Los Gatos Bank, and an organizer of the Los Gatos Gas Company, Lyndon was one of five trustees when the town was incorporated in 1887. (Courtesy of the Museums of Los Gatos.)

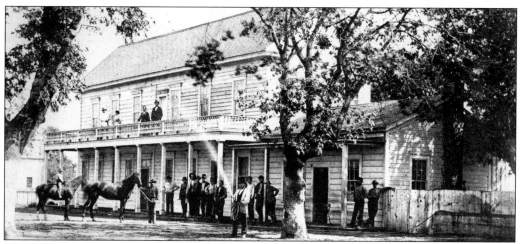

TEN MILE HOUSE. In 1860 a man named Gleason built the "Ten Mile House," a shanty located on the east side of Santa Cruz Avenue, about where the Southern Pacific depot and freight sheds were later constructed, and the current site of the Town Plaza. The hotel was ten miles from San Jose and was the last watering place for rugged lumbermen traveling from San Jose to the Santa Cruz Mountains. In 1862 Gleason sold the property to Henry D. McCobb, who enlarged the building. The *San Jose Mercury* announced in its April 1–7, 1865 issue that "H.D. McCobb has been commissioned postmaster at Los Gatos, and has entered upon the discharge of his duties by fitting up a neat little triangular office in one corner of the barroom of his hotel, where he will dispense epistolary missives and the latest news to the eager multitude. Truly Los Gatos is getting to be a town of considerable note." When John Lyndon became proprietor in 1868, card tables at the Ten Mile House were always crowded, some players sitting in front of stacks of $20 gold pieces. This photograph is dated 1875.

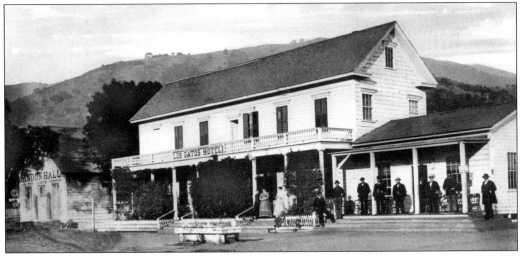

THE LOS GATOS HOTEL, C. 1883. When the narrow-gauge railroad came to town in 1878, John Lyndon deeded land to the South Pacific Coast Railroad with the provision that his hotel be moved across the road, to the north and west, to the corner of what today is Main Street and Santa Cruz Avenue. The hotel survived the move, was remodeled at that time, and rebuilt in 1883. To the left is Lyndon Hall, the site of community meetings, dances, entertainment, and the place where many Los Gatos churches had their inception. The wooden watering trough near the hotel entrance served as a popular spot for farmers to water their horses, and it had a faucet for human drinkers on one end. For a 10¢ fee, the driver could water his team and receive a drink of whiskey at the bar. An 1884 advertisement in the *Los Gatos Weekly News* states that "the table is supplied with the best in market. Constantly on hand are the very best brands of English Ale, Porter, and French Wines. Rates per week are $5 to $9, according to room."

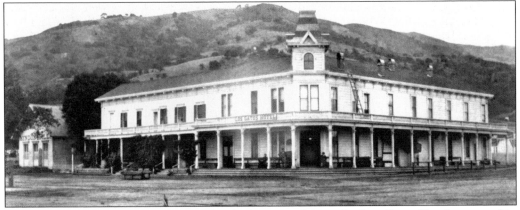

THE LOS GATOS HOTEL, C. 1890. After further remodeling, the Los Gatos Hotel appeared in New Orleans Colonial Style, with an "L" section added along Main Street in 1890. The newspaper reported, "The new addition is large, has fine rooms and is being furnished with fine antique oak sets. An electrict [*sic*] enunciator is being put into the house so that each guest will be in direct communication with the office." But on May 26, 1898, the hotel was destroyed by fire when a lamp exploded in Room 64 on the first floor. The newspaper reported, "Owing to the fact that it was of wood, old, dry and inflammable, it burned like tinder." Only the front walls were left standing, and firemen Al Williams and Arthur Bond were injured in the fire. J.W. Lyndon's losses were estimated at $15,000, and lessee C. W. Gertridge lost $8,000 in furniture and personal effects.

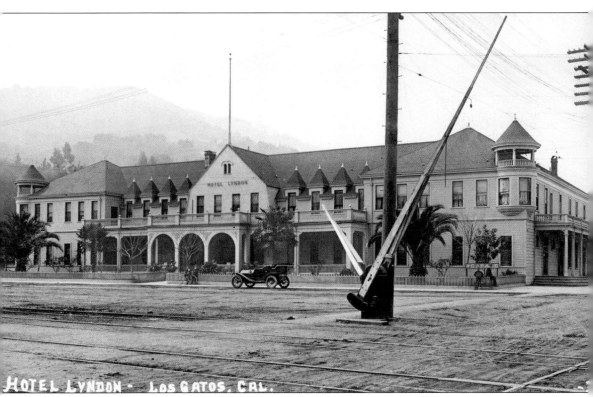

HOTEL LYNDON - LOS GATOS, CAL.

HOTEL LYNDON. The grounds were cleared of debris and plans made for a new hotel. The Hotel Lyndon had 175 feet of frontage on Santa Cruz Avenue and was set back about 30 feet from the street "to give room for a handsome front." Jacob Lenzen & Son of San Jose were the architects, E.A. Hettinger of Palo Alto was the contractor, and R.C. Andrus, "who built the Los Gatos School building in 1886," was foreman. According to newspaper reports, nearly all of Los Gatos attended the grand reopening on June 1, 1899. After dinner the double dining rooms were cleared of tables and chairs, which were placed on the "wide, brilliantly illuminated front porch and used in serving ices to the many guests during the evening." Dancing then commenced in the dining rooms to the music of Brohaska's Orchestra. The parlors, sitting rooms, and bedrooms not occupied by guests were thrown open for inspection. "The rooms are all carpeted with velvet carpets of various designs and shades and the furniture is nearly all light, birds-eye maple, ash and oak. The inside finishing of the hotel is in natural wood—southern pine, oak and redwood." Each of the 60 bedrooms was furnished with the same grade of hair mattresses and linens. Of special note was the gentlemen's sitting room, known as the Indian Room, with Navajo hangings, rugs, baskets, and pottery, and "other Indian bric-a-brac." The ladies parlor was "restful with easy chairs, paintings and engravings and its piano." Lumber to construct the hotel amounted to 300,000 feet, much of it redwood, from James Lyndon's lumber yard. A road extended entirely around the hotel.

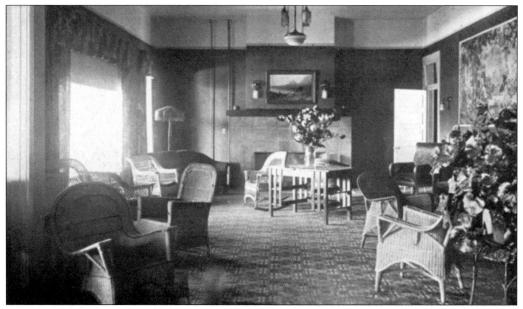

MEMORIES OF THE LYNDON. Many people arrived by train in Los Gatos and remembered spending their first night at the Hotel Lyndon. There were spacious gardens and cottages to the rear of the main building. For nearly 64 years the hotel held an important place in the cultural identity of the town. The wooden watering trough was in place until 1907, when the women of the History Club petitioned the town to replace it with a "modern concrete decorative trough." Plans made in 1962 to remodel the building into a "theater-restaurant-luxury hotel" did not pan out. This photograph of the interior of the hotel is undated. (Courtesy of the Museums of Los Gatos.)

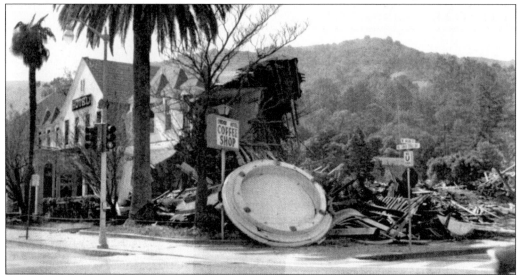

BUILDING DOWN. A demolition permit for the Hotel Lyndon was issued on March 30, 1963, and the task was accomplished in a day. The furnishings had been sold at auction ten days earlier. Writing in 1986, local newspaperman John S. Baggerly asked, "Remember the day they tore down Los Gatos?" He lamented that during the period of 1954–1968, postcard landmarks dissolved from the downtown scene. (Courtesy of the John Baggerly Collection, *Los Gatos Weekly Times*.)

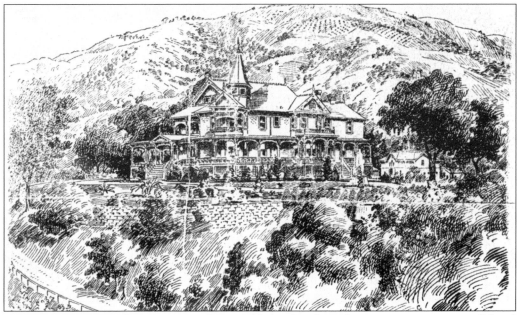

LYNDON HEIGHTS. This artist's rendering of John Lyndon's home was run in a small local newspaper in 1895. The artist took the liberty of moving the carriage house, shown at the right, from the rear of the house to the side. Occupants of the carriage house were John Lyndon's two favorite horses, Fairyfoot and Firefly. The house was located on a hill south of the Lyndon Hotel, with a sweeping view of Los Gatos and the Santa Clara Valley, the current site of Los Gatos Meadows retirement community. Construction cost was about $12,000. In 2003 the cupola from the carriage house was gently placed atop the Lyndon Bandstand located at Oak Meadow Park.

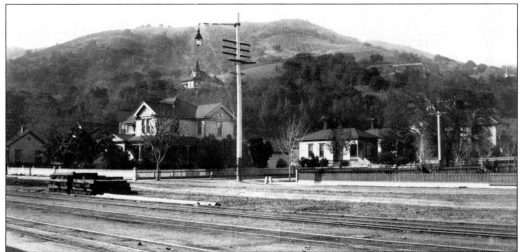

LYNDON HOMES. This photograph from historian Clyde Arbuckle's collection, taken from the train depot, shows the home of James Lyndon at South Santa Cruz and Broadway, surrounded by a white picket fence. The Lyndon families would sometimes gather on the front porch of this home to socialize. Lyndon Heights can be seen sitting on the hill above. Also visible in the foreground is the "third rail," added in 1895 to accommodate standard-gauge trains. (Courtesy of the California Room, San Jose Public Library.)

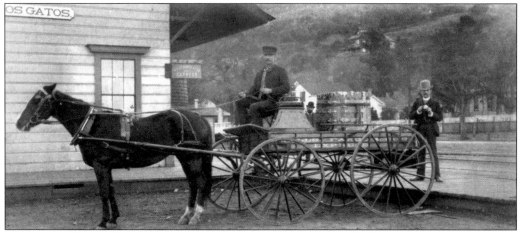

First Los Gatos Train Depot. In 1878 the first wood-burning engine chugged into Los Gatos on narrow-gauge tracks, coming from the Alameda ferry, through San Jose to Los Gatos. The train had eleven cars filled with notables invited by South Pacific Coast Railroad president Alfred "Hog" Davis. Los Gatos remained the terminus until May 15, 1880, when the route over the mountains to Santa Cruz was opened. Within a week 15 celebrants sitting on benches in excursion-train flatcars traveling over the mountains, died when the train jumped the track and they were thrown along the right-of-way. This *c.* 1886 photograph shows a Wells Fargo wagon with George Fletcher holding the reins. George Wilson, the station agent, stands behind.

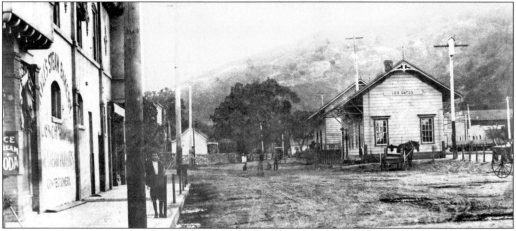

Boy Trouble. A Los Gatos lad in knickers leans on a hitching post and smiles for the camera, sometime after 1904. "Oak Street" changed to "Front Street" in 1895 and is now Montebello Way. It was also known as "Chinatown," and held special attractions for the boys in the village. Jumping on and off moving trains and swiping fruit from boxes waiting for shipment were two notable transgressions. Boys would save their money for months before the Fourth of July in order to go to Sing Lee's Laundry at 23 Front Street to buy Chinese firecrackers, considered far superior to the domestic product. Peeking through the windows of the laundry to watch the laborers fill their cheeks with water and spray clothing to be ironed was another pastime. During the 1901 fire, when his laundry was threatened, Sing Lee bundled all clothes in his care into his wagon and hauled them off to safety. His own clothing—both "China clothes" and American—along with his furniture that had been purchased for his late wife, 1000 pounds of soap, and his winter stock of wood and hay were left to their fate. One of the other buildings on Front Street was a saloon called The Buffalo.

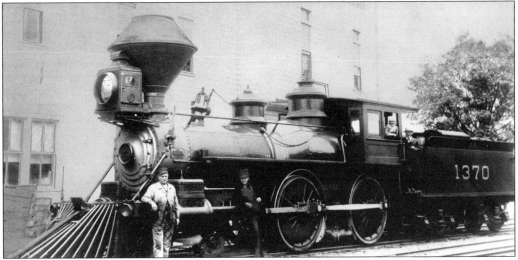

FIRST ENGINE ON BROAD GAUGE, 1895. Before long the narrow-gauge became dated. Standard-gauge rails were welcomed, especially by farmers who could now ship their products straight through instead of having to shift cargo at San Jose to the broad-gauge track. This old wood burner was built in 1886. The diamond smoke stack was devised to catch cinders from the wood fire and thereby prevent fires along the right-of-way. The shiny boiler was the responsibility of the fireman, who took great pride in working it over with mutton tallow and lamp black. The tallow was obtained free from friendly butchers along the run and protected the boiler against rain. The headlight was powered by coal oil and the cow catcher was made of wood. In the cab are Curt Roemer of Los Gatos and his son.

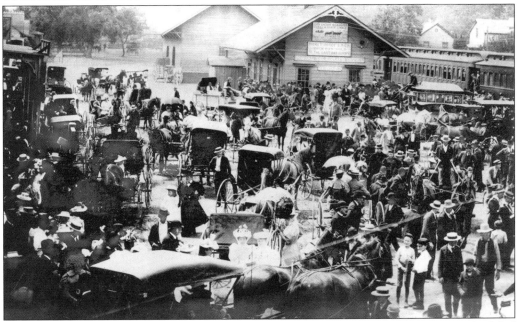

BROAD-GAUGE CELEBRATION. On April 15, 1900, a large crowd meets the first scheduled passenger train to arrive on broad gauge. People came from surrounding cities to help celebrate the event, and a picnic was held at Bunker Hill Park. The town placed a tower and drop gate across Main Street that year.

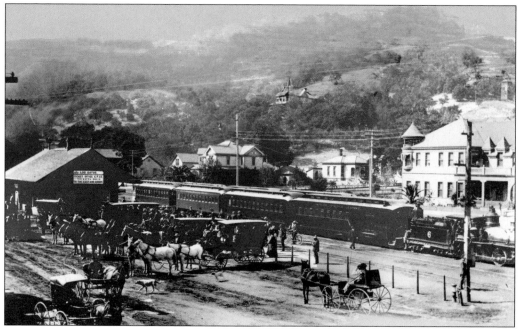

HORSE-DRAWN "HACKS." In this early photo, the depot advertises "Tickets to the East and Europe." The horse-drawn buses are backed up, waiting to take passengers to their destinations, often to hotels, including the El Monte. Lyndon Heights can be seen at the top, center of the photo, and the Hotel Lyndon is at right.

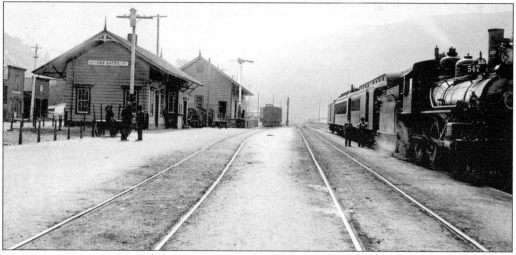

LETTING OFF A LITTLE STEAM. Work was progressing on the construction of broad-gauge tracks over the mountains when the April 18, 1906, earthquake struck. The tracks between Alma and Wright's buckled and were covered with slides and boulders. The water tank at Wright's went over and through the bridge, and the one-mile tunnel from Wright's Station to Laurel was impassable, with the tunnel floors raised as much as three to four feet in places. After more than three years, on June 11, 1909, train service resumed over the mountains to the sea with 14 trains scheduled daily. The route reopened with "elegant standard-gauge trains, equipped with every modern convenience." This c. 1910 photograph at the Los Gatos station shows a Southern Pacific train on standard-gauge rails. The narrow-gauge rails had been pulled up in 1909.

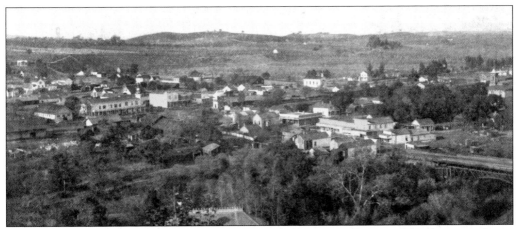

LOS GATOS, C. 1887. Prosperity was just around the corner. Fruit and lumber were being hauled out of the Santa Cruz Mountains by the trainload. Six, eight, and even ten horse teams with jingling bells pulled lumber wagons to San Jose. Orchards were established on the valley floor, replacing wheat fields. This view was taken from College Avenue, looking northward toward the rolling hills of the future Monte Sereno. The towered building, far right, is the 1886 elementary school building, with the old wooden bridge (1882–1906) shown at lower right. Los Gatos Hotel appears on the left. The 1881 Catholic Church, just right of center, stood on the southwest corner of North Santa Cruz Avenue and Bean Avenue. About this time an editorial in the *Los Gatos News* noted that in warm weather the lack of sewers came "forcibly to the notice of everyone" who walked along the streets, especially Main Street. To meet such challenges, the town of Los Gatos incorporated on August 10, 1887, including about one square mile on each side of the creek. The population in 1887 was 1,500.

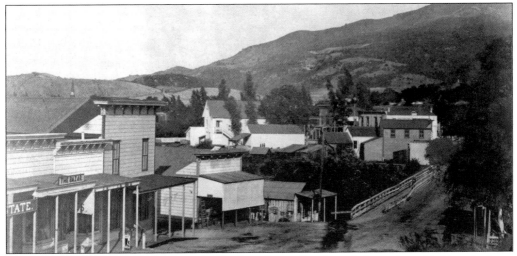

MAIN STREET BRIDGE, 1882–1906. The Los Gatos Creek and the series of bridges built to span it, beginning *c.* 1840, have always been important landmarks. Winter rains washed away some of the earliest wooden structures. This bridge opened for horse-and-buggy traffic May 13, 1882, and also provided pedestrian guard rails on both sides. False-front buildings with wooden awnings create a scene resembling a western movie set. Muddy dirt streets sometimes had to be shoveled to cut a path for pedestrians. In 1886 the local newspaper declared that the streets were "well-nigh impassable except to men in boots and women in bloomers and boots." Installation of redwood plank crossings was recommended.

43

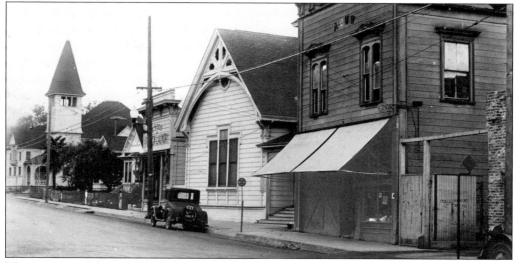

MURDER AND MAYHEM. Los Gatos and the mountains beyond had their share of lawlessness during the early years of the town. Stage coach robberies, murders, horse thievery, cattle rustling, Tiburcio Vasquez the Lover Bandit, and a school teacher who turned to crime were all a part of the scene. An 1880s saloon keeper, operating on the north side of West Main Street, was said to have a trap door to his cellar, where he would throw drunks after robbing them, covering the bodies with lime. This photograph shows the same area of West Main Street in 1927. The towered building at far left is the First Baptist Church, built in 1889, and an earlier Baptist Church has an automobile parked in front. Both were purchased by the Christian Church in 1917.

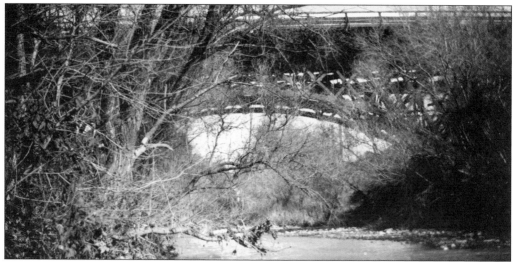

HANGMAN'S BRIDGE. It is hard to imagine a more idyllic scene than the one pictured here, taken sometime before 1906. However, during the 1880s the American West was still crude, wild, and raw, and the citizens of Los Gatos grew incensed when a series of murders went unpunished. On Sunday afternoon, June 17, 1883, at about 3p.m., a young Californio named Incarnacion Garcia was hung from this bridge by members of a local vigilance committee, seeking "even and exact justice, without cost to the county." Vigilante hangings were fairly commonplace in the 19th century. Placerville, in the gold country, was at first named "Hangtown." The old wooden bridge was forever branded as the "Hangman's Bridge." The local newspaper from this time period certainly covered news of the hanging, but all copies are missing from the library's collection.

44

LOS GATOS JUSTICE.

Incarnacion Garcia Slays Rafael Mirivale.

SWIFT VENGEANCE UPON THE SLAYER.

A Fatal Plunge Into Eternity from the Railing of a High Bridge. A Village of Knownothings.

SAN JOSE DAILY MERCURY, TUESDAY MORNING, JUNE 19, 1883, PAGE 3. The major newspaper in San Jose covered the story of the Los Gatos hanging in a full-page, 5,000-word article. The *Daily Mercury* reporter traveled to Los Gatos on June 18, 1883, to attend two consecutive inquests, convened at 1 p.m. by Santa Clara County coroner J.T. Harris, with Constable E.F. Reynolds in attendance. The first inquest was for Rafael Mirivale, who had apparently been stabbed to death near the entrance to Lyndon Hall by Incarnacion Garcia, after a disagreement while "playing a game of crib" in the saloon of the Los Gatos Hotel. The second inquest was for Garcia himself, who had been hung on the Main Street Bridge within a half hour of Mirivale's death. The inquests were held at Lyndon Hall, "in the presence of the two ghastly cadavers." Witnesses sworn at the inquests included Cary Daves, N.B. Terwilliger, Z. Wheaton, Charles Johnson, Leonardo Medina, J.F. Renchler, F.W. Perkins, H. Sincock, C.H. Goslaw, George Root, Otis Blabon Jr., J.H. Lyndon, Patrick Mullen, H. Berryman, Alfred Hoyt, T.W. Clelland, Samuel Templeton, and Isaac Lundy. Although many of the witnesses recalled seeing up to 200 men, women, and children on the bridge around the time of the hanging the previous day, no one could recall the names of those in attendance, and no one knew who removed Garcia from the "village calaboose," known as "the sweat-box." The jury's verdict was, "We find no evidence to implicate anyone."

HIS APPEARANCE.

CHARLES HENRY GOSLAW, HANGED. On the evening of January 19, 1887, Charles H. Goslaw, age 35, entered the Johnson Avenue cottage of his business partner Henry A. Grant and beat the older man so severely that Grant died two days later. Goslaw was angered that Grant had shipped to San Jose "the rollers he had been using to move the Episcopal Church." Goslaw was arraigned for murder in the court of Justice Wilder. J.P. Hill, Henry Grant's next door neighbor, witnessed the crime, and Goslaw was convicted of murder in the first degree. Goslaw was hanged on the gallows at San Jose on November 25, 1887, with 200 people in attendance. The *Los Gatos News* of December 2, 1887, published letters he wrote to his wife and children and to the public on the morning of his execution, in which he proclaimed his innocence, and asked his wife to shield his children from knowledge of how he had died. In 1931, town father N.E. Beckwith recounted a conversation with newspaperman William S. Walker, in which Mr. Walker stated that Charles Goslaw had "stamped the fingers of the victim as he clutched at the bridge."

GRANDFATHER HENRY GRANT. This photo, credited to L.S. Rendall of Santa Rosa, California, shows Henry Grant with his granddaughter Hattie, *c.* 1875. The day after Charles Goslaw was hanged, the *San Jose Mercury Herald* reported, "Goslaw, it is said, was one of the participants in the Los Gatos lynching several years ago. It was an occasion of intense excitement, and Goslaw did no more than scores of other and most reputable residents of that little town." The *San Jose Daily Evening News* editorialized on November 28, 1887, that public executions always portray the criminal as a "man of nerve," and the community suffers most. The man to be hanged "has become reconciled to the situation, and the affair is a sort of picnic to him."

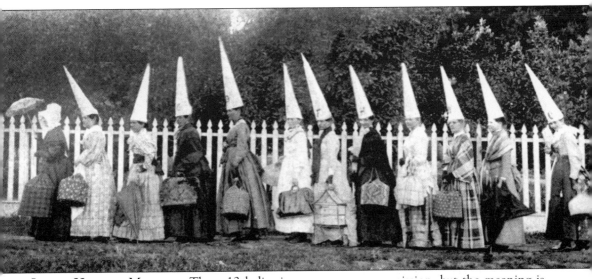

LOCAL HISTORY MYSTERY. These 12 ladies-in-a-row were on a mission, but the meaning is unknown. The photo was taken *c.* 1885, probably at the McMurtry house on Mill Street (now Church Street), near Forbes Mill. The McMurtry home was the first real house in Los Gatos, built *c.* 1860 by a Mr. Samuels, and was often called the "old mill house." W.S. McMurtry planted about 400 orange trees around his home, proving how well fruit would grow in Los Gatos. The Los Gatos Women's Christian Temperance Union was organized in 1885, and these women, with letters on their pointed hats and carrying birdcages, may have been marching for the cause of temperance. The drinking that had been a favorite pastime in frontier days wasn't acceptable to many of the wives and mothers busy creating communities. Early members of the WCTU included Mrs. Laura Lee, Mrs. M.C. Proctor, Mrs. George Hart, Mrs. R. Moody, Mrs. W.S. McMurtry, Mrs. Cox, Mrs. Hyde, Mrs. W.S. Walker, Mrs. Holliday, Dr. Mary Mallory, Mrs. Shafer, Mrs. Briggs, Mrs. Grey, and Miss Ella Shove. Members of the WCTU were also involved in other causes, including women's suffrage and the campaign for the eight-hour work day. "Gray's WCTU Restaurant" stood between the depot and the bridge. This photograph may capture the first protest march in Los Gatos. (Courtesy of the Museums of Los Gatos.)

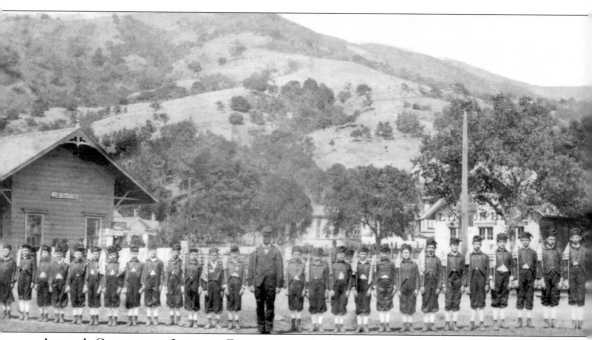

ANDRU'S COMPANY OF JUVENILE ZOUAVES, 1885. The 1885 Fourth of July celebration in Los Gatos was sponsored by the local WCTU. A "Card of Thanks" appears in the *Los Gatos News* of July 17, 1885, expressing gratitude to the WCTU for its work and to Mrs. Hart and Mr. R.C. Andru for the formation of the Zouaves. The Zouave uniforms were derived from French Algerian mercenaries and adopted by units in the American Civil War. The newspaper notes that Mrs. Hart had managed to have all the boys dressed in homemade uniforms for the celebration. Mr. Andru's role was to introduce the boys to military tactics and drills and honor the memory of the Civil War. The WCTU felt it necessary to have "patriotic and sober people conducting the exercises of our natal day," and they indignantly denied that liquor was being sold on Mr. Shore's picnic grounds that day. The Zouaves are mentioned again that summer as participants in the Los Gatos memorial exercises of August 8, the funeral day of General Ulysses S. Grant, who served as 18th President of the United States. Reflecting what happened nationally, the town was draped in black early in the day, and at noon business was suspended. The procession formed at 1:30 p.m. under the direction of Thomas Shannon. The Grand Army of the Republic, under James Lyndon, occupied the right, the Ancient Order of United Workmen was next, and the Juvenile Zouaves were on the left. (Courtesy of the Museums of Los Gatos.)

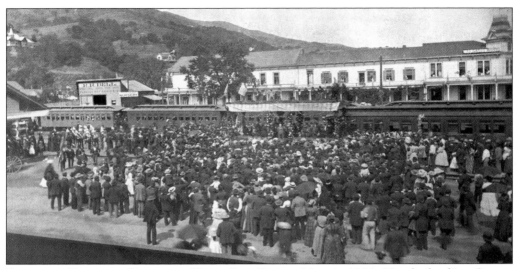

PRESIDENT BENJAMIN HARRISON VISITS LOS GATOS, MAY 1, 1891. Hundreds of Los Gatans crowded the train station to greet President and Mrs. Harrison and some members of his cabinet as they traveled through California on a special train. The *Los Gatos News* reported, "the depot and a flat car were handsomely decorated with flowers, ferns, evergreens, and grasses, and bunting was liberally displayed from the neighboring flag-staffs." President Harrison, the portly man seen on the flat car platform, explained that, "We can only tarry for a moment," and then expressed his great surprise at seeing vineyards and orchards flourishing in the mountains, "which rival in productiveness the famous valleys of your state." Three rousing cheers were given at the end of the president's speech, and gifts were given to the presidential party, including "a luscious basket of Los Gatos oranges," presented by C.F. Wilcox.

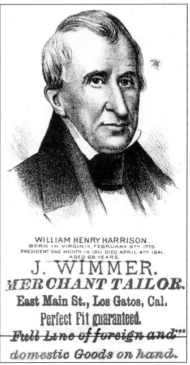

EARLY ADVERTISEMENT. J. Wimmer, the merchant tailor on East Main Street, handed presidential cards to his customers. Benjamin Harrison's grandfather, William Henry Harrison, is pictured here. Young Benjamin Harrison spent many hours in the 1840 campaign headquarters of "Old Tippecanoe," who won the election, only to die one month after his 1841 inauguration. He had delivered a two-hour address on a frigid, rainy day and caught cold.

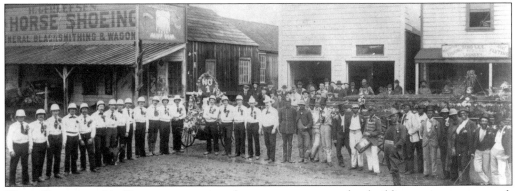

HOSE COMPANY #1. Fire was a constant threat as soon as wooden buildings were constructed. The January 21, 1903 *San Jose Mercury Daily* sympathized that "during the past twelve years, fire has been the most persistent and pitiless foe with which Los Gatos has had to contend." Before 1886, Los Gatos could depend only on volunteer bucket brigades for protection. Soon two volunteer firefighting companies were in place, one on each side of the bridge. This photo shows Hose Company #1, located on land leased to the town in 1894 by J.W. Lyndon, just opposite the depot. The two companies were separate organizations and rivalry frequently flared into water fights at town picnics. Dick Shore, standing under the "No 1," was fire chief for 18 years. Some firemen appear in "black face" in this photo. Sing Lee's Laundry is seen at right. (Courtesy of Elayne Shore Shuman.)

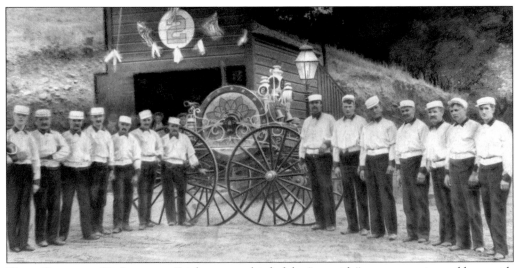

HOSE COMPANY #2. Lawrence Erickson was chief of the "east side" company, pictured here with their elaborately decorated hose wagon. Notable early fires in Los Gatos included the 1888 Cooperative Winery fire, when gas escaped from one of the stills and was ignited by a lantern. The building was destroyed in a hot fire fueled by 1,000 gallons of brandy. On August 19, 1890, George Seanor's 1885 600-seat Opera House on East Main Street, near Church Street, was burned to the ground. Dr. F.W. Knowles arose early that Sunday morning to go hunting, discovered the fire, and ran to the Presbyterian Church to ring out the alarm. The hose cart was run out and attached to the hydrant, but the water supply was slight, and a number of buildings burned, including John Erickson's wagon shop. The new Methodist Episcopal Church and the Presbyterian parsonage were saved. The fire may have been caused by a "lighted cigar thrown carelessly down" at the Republican campaign meeting the night before at the Opera House.

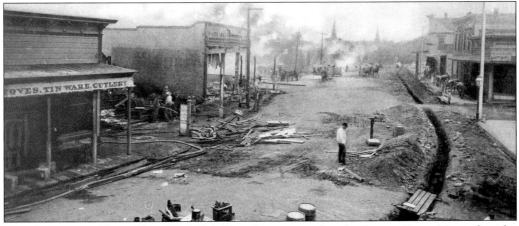

THE CARTRIDGE FIRE, JULY 27, 1891. Less than a year after the Seanor Opera House fire, the town was once again visited by "the terrible red monster." The disastrous Cartridge fire of 1891 started on a Sunday evening in the wooden finishing rooms at the rear of the Place and Fretwell Furniture Store on the north side of East Main Street. The bells in the nearby Presbyterian Church again sounded the warning. Furniture was removed from the Arlington Hotel at 47 East Main Street, but the building with its tower and turrets collapsed within an hour. Cartridges exploded in the H.J. Richardson Hardware Store, and gun powder stored in a tunnel in the side of a hill scattered earth and stone in every direction. The fire destroyed buildings on both sides of East Main Street, from the bridge to the present College Avenue, but the bridge was saved. Lewis Stoves and Tinware is in the foreground. Damage was estimated at $150,000.

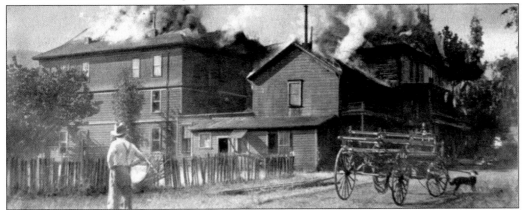

THE EL MONTE HOTEL (1891–1909). Located on the northeast corner of East Main and Pleasant Street, this hotel was originally the Coleman House, then enlarged and successively named the Alpine, the Rockhaven, and finally the Hotel El Monte. It was advertised as "Positively the Only First-Class Hotel in Los Gatos," and featured 500 feet of porches, ten feet wide. Social events were attended by the elite in full evening dress, who danced to fine orchestras and ate food prepared by chefs from some of San Francisco's finest restaurants. The El Monte was apparently targeted several times by an arsonist in the early 1900s, and burned to the ground on July 3, 1909. The *Los Gatos Mail* reported in its July 8, 1909, edition that "the destruction was swift and complete." Most of the furnishings and personal belongings of the guests and employees were rescued, and no one was injured. The article stated that "with the present prices for material and labor," the hotel could not be rebuilt for less than $35,000 or $40,000. The owner, Mrs. W.W. Gray, carried only $5,000 insurance on the building, and it was never rebuilt. The El Monte was the sometime-home of Ambrose Bierce in the 1890s.

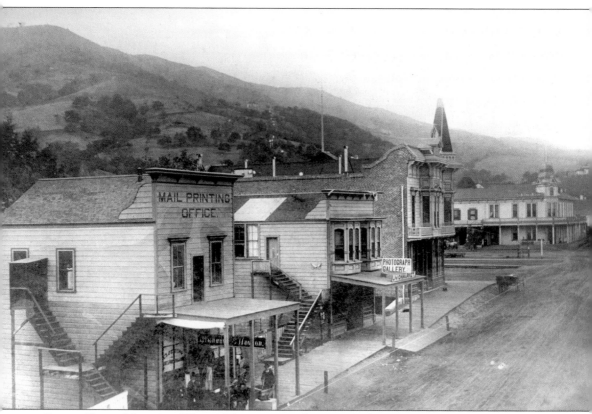

SMALL TOWN MADE OF WOOD. This *c.* 1890 photograph shows, at left, the offices of the *Los Gatos Mail* newspaper, established in 1883 by H.H. Main, an editor of the *San Jose Herald*. The *Mail* was in competition with the *Los Gatos Weekly News*, established in 1881 by William S. Walker. In the following years a number of local newspapers lived and died. This view is Main Street looking west, showing a little western town constructed almost entirely of wood. Between the 1891 Cartridge fire and the 1909 El Monte Hotel fire, there were many more conflagrations. The beautiful Johnson Opera House, built near the site of the burned Seanor Opera House, opened in 1883 and was called the "Pride of Los Gatos." Within 18 months, on August 24, 1894, it too burned to the ground. In 1898, the Los Gatos Hotel, shown at the far right, burned down. Early on the morning of June 14, 1899, an 1887 building, owned by W.B. Rankin on the north side of Main Street at the west end of the bridge, burned to the ground. The post office, the French hotel and restaurant, M.A. Powell's barber shop, and David Bostwick's cigar store were all destroyed, despite quick response from Hose Companies #1 and #2 and the hook and ladder company. The buildings shown above, up to the railroad tracks, were burned to the ground in the great fire of October 13, 1901, the worst fire of all. The old wooden buildings "went up like paper," despite an improved water supply, a fire bell, and the best efforts of the "fire laddies" and other residents who fought to save the town.

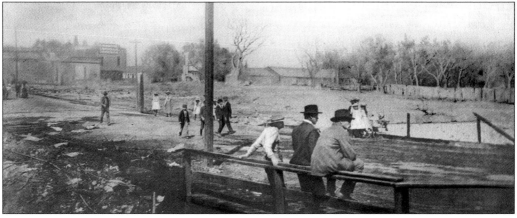

THE LIVERY STABLE FIRE, OCTOBER 13, 1901. A little more than ten years after the 1891 fire, a catastrophic blaze destroyed much of the business district, this time on both sides of West Main Street, between the bridge and the railroad tracks, leveling up to 60 buildings. A local newspaper reported on October 17, 1901, that telephone messages and telegrams were sent to San Jose and San Francisco, but no response was received on that early Sunday morning. The fire started at the rear of a bakery on Park Avenue and soon spread to Tisdale's Stables (formally the Lyndon Hotel Stables). Eight horses died, including a handsome matched black team that Mr. Tisdale had recently purchased in San Jose. One horse ran as far south as the first trestle on the railroad, but returned to perish in the burning stable. The fire spread up University Avenue, claimed the Episcopal Church, and set fire to the school "half a dozen times." When it was over the school and the Main Street bridge were saved, but the only building left standing on West Main Street was the Public Reading Room. After this fire in 1901, the business district of town turned north on Santa Cruz Avenue.

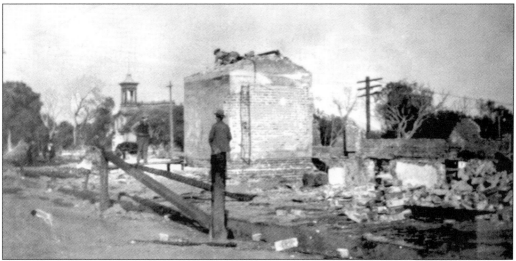

REMAINS OF THE DAY. The weather had been hot for several days preceding the 1901 fire, with a total lack of dew or fog. The wind was blowing briskly on the morning of the blaze, creating ideal conditions for the fire to spread rapidly. Townspeople noticed a "lurid light" reflected from the mountain sides during the fire and heard tin roofs pop. The vault of the ornate Commercial Bank, shown in the center of this photo, survived, a testimony to its 21-inch thick walls, lined in steel. The bank was located at the southeast corner of West Main Street and Front Street (now Montebello Way). Wooden sidewalks lie crumpled in the foreground.

DEVASTATION. A young girl in pigtails stands on the Main Street bridge soon after the 1901 fire, gazing north toward the towered school house, one of the few buildings to survive. Remarkably little debris remained after the fire. "All that remains of a good sized building would not make a wheel barrow load," stated a local newspaper. The wood was gone, and only pipe, wire, glass, cans, and dishes remained. Even so, the wind blew ashes into the classrooms for days. The WCTU drinking fountain on West Main Street continued to function.

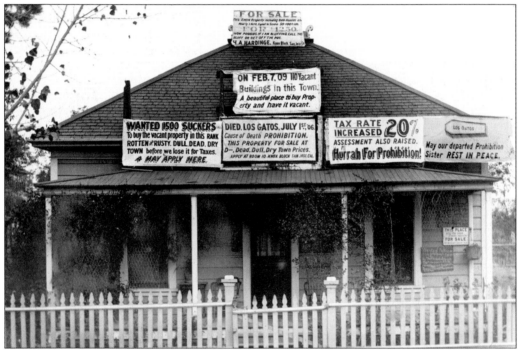

"WANTED—1500 SUCKERS." Beyond the numerous fires of the late 19th and early 20th centuries, another kind of conflagration raged in Los Gatos for more than 20 years. The fight over prohibition, between the "wets" and the "drys," started in Los Gatos in the 1880s and was only partially resolved by 1910, when it was agreed that liquor could be sold, but only "with bonafide meals in hotels and restaurants." The signs on this house, which now stands on Fiesta Way, declare the death of Los Gatos on July 1, 1901, from Prohibition. At one point a coffin rested on the roof. A local tale recounts that in 1889 there were nine "tippling places" in town when the town fathers decided they must be licensed. One saloon-keeper was so incensed that he left town, pulling his saloon building down Main Street behind a four-in-hand, driven by a thirsty-looking teamster, followed by a crowd of thirsty customers. Some saloons tried to stay in operation despite the local laws.

THE GRAND ARMY OF THE REPUBLIC. This society was limited to "veterans of the late unpleasantness," who fought for the North in the Civil War (1861–1865). Los Gatos Post No. 82 was organized September 4, 1885, and named for Union General E.O.C. (Edward Otho Cresap) Ord (1818–1883). Thomas Shannon was installed as the first commander and James H. Lyndon as the first quartermaster. At the conclusion of the ceremonies, "the company repaired to Lyndon Hall where a splendid collation had been prepared by the ladies." After the supper, "several of the old war songs were sung with zest." The GAR led the town's Memorial Day observances until its membership became too small. Memorial Day was called "Decoration Day" when first celebrated in 1868 at Arlington National Cemetery, which held the remains of 20,000 Union dead and several hundred Confederate dead.

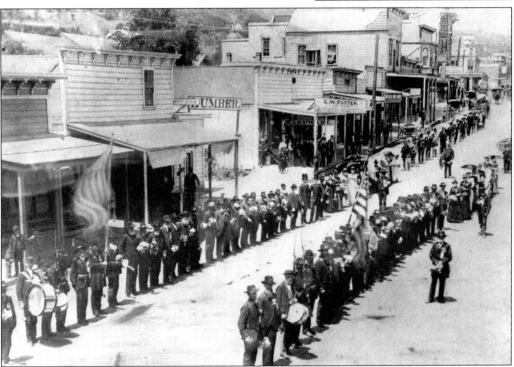

MEMORIAL DAY, 1891. This view is on East Main Street looking west, near the site of the current Civic Center. The 1896 Los Gatos GAR roster lists members' occupations as orchardists, ministers, ranchers, carpenters, merchants, barbers, physicians, bankers, editors, and many "fruit growers." They had served in units from New York, Illinois, Wisconsin, Minnesota, Pennsylvania, Iowa, Michigan, Ohio, Missouri, New Jersey, Maryland, Indiana, Oregon, Massachusetts, and Vermont. A few were from California, but most had come west after the war.

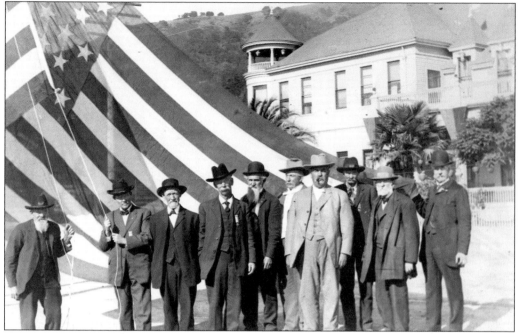

GAR SURVIVORS, 1917. These ten dapper men were the surviving members of E.O.C. Ord Post, No. 82, GAR in 1917, when this photograph was taken at a flag-raising ceremony on Santa Cruz Avenue 52 years after the end of the Civil War. The Lyndon Hotel is in the background. One of the last survivors, Commander W.H. Lawrence (1837–1935) was 98 years old at his death. He had escaped from Andersonville prison, but was recaptured before he reached northern lines. The last member of the local chapter, James A. Thom, died in 1937, and the organization ceased to exist. The torch was passed to the Los Gatos Sons of Union Veterans.

"But his soul goes marching on."

JOHN BROWN'S BODY. This early postcard refers to John Brown, the abolitionist whose body "lies a-mouldering in the grave." In 1883, the *Los Gatos Weekly News* reported that Mr. Thomas Gray "sold the fine old mountain ranch above Saratoga to Mrs. Brown, widow of the immortal John Brown of Harper's Ferry fame." Mrs. Mary A. Brown and her younger daughters had crossed the plains by covered wagon in 1864. Local papers reported that in 1913, at the 28th anniversary of the Los Gatos GAR Post, John Brown's daughter Sarah presented a life-sized picture of her father to the organization. A picture of her mother, who died in 1884, was presented to the Women's Relief Corps.

Three
PROSPERITY

There is no substitute for hard work.
—Thomas Edison

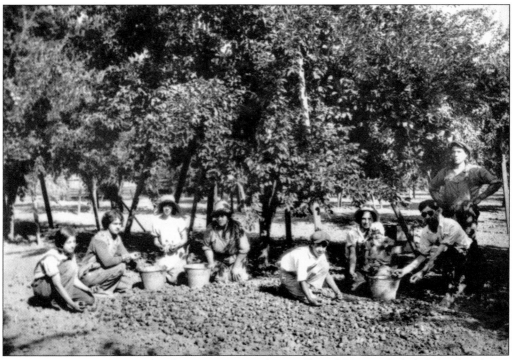

PRUNE PICKERS. Thousands of prune trees in the "Valley of Heart's Delight" produced 100 million pounds of fruit annually to be picked, dried, packed, and shipped. Entire families supplemented the itinerant labor supply, and if the crop had to be harvested late, local school openings were delayed so students could help. In this photograph, tree limbs heavy with fruit are supported by poles. Often at harvest prunes were shaken to the ground rather than picked. Summer work was easy to find at the canneries and in the drying yards. From a Los Gatos population of 3,168 in 1930, 400 were employed for the season at Hunt Brothers Cannery.

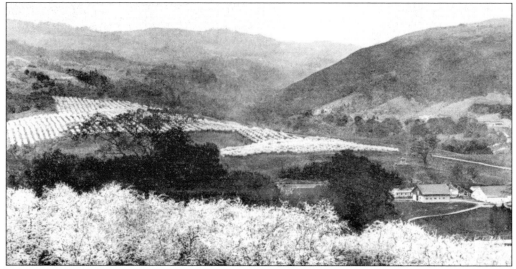

GARDEN SPOT OF THE WORLD. The Los Gatos area, located in the Santa Clara Valley, was known as one of the finest agricultural districts in the world. The fertile soil, mild climate, long growing season, and abundant sunshine resulted in the chamber of commerce claim that "there is no fruit that surpasses that which is grown along our foothills for fineness of grain, flavor, and amount of sugar, and it always brings the highest price in the open markets." Early orchardists of the 1870s included J.F. Kennedy and Harvey Wilcox. In springtime the air held a subtle, sweet perfume, and in late summer the rich smell of drying fruit.

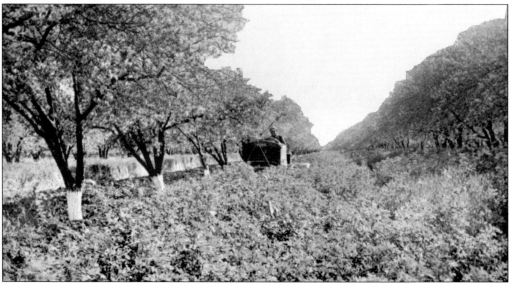

HORTICULTURAL ALPHABET IN THE VALLEY OF HEART'S DELIGHT. "Apricots, almonds, apples, argols, brandy, blackberries, cherries, canned fruits, currants, chestnuts, dried fruits, dewberries, egg-plums, figs, filberts, fruit juices, grapes, guavas, gooseberries, honey, jellies, Japanese fruits, lemons, limes, loquats, mulberries, marmalade, nectarines, olives, oil, oranges, prunes, peaches, pears, plums, persimmons, pomegranates, quinces, raspberries, rhubarb, strawberries, tangerines, unutterable variety of vegetables, vinegar, wines, and walnuts make part of the alphabet of our fruit-products"—a list supplied by the chamber of commerce in the early 1900s. (Courtesy of the Museums of Los Gatos.)

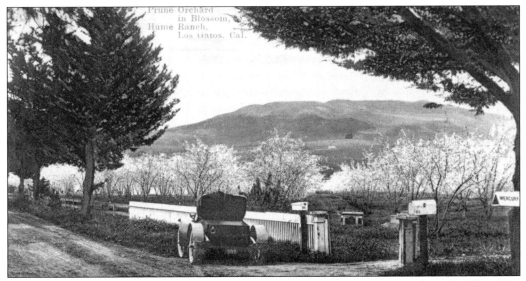

LARGEST PRUNE ORCHARD IN THE WORLD. For many years the Hume Ranch in the Glen Una District, located halfway between Los Gatos and Saratoga, had the largest prune-bearing orchard in the world, with about 350 acres of French prunes planted. The ranch was owned by Dr. G.W. Handy of San Francisco, who kept a summer home there and who had a daughter named Una. Up to 60 Japanese laborers worked at the ranch at one time and were charged room and board, taken from their monthly salaries. J.D. Farwell (1872–1943) was manager of the Hume Ranch for 25 years. The ranch was an early supplier of electricity for the town. This postcard photograph is *c.* 1908 by M. Rieder.

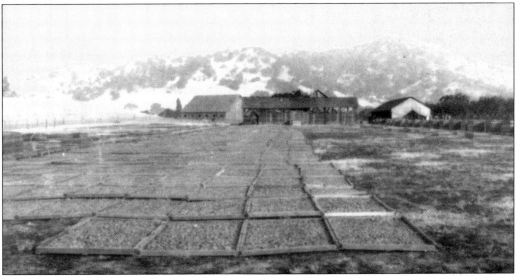

THE PRUNE YARD. Huge prune crops led to the discovery that prunes could be dried in the sun, a much cheaper and more efficient process than drying in evaporators, which had been done previously. Nearly every ranch had a dry yard in summer, where fruit was laid out to dry in six-foot wooden trays. First the prunes were dipped in lye to tenderize their tough skins. In larger operations, perforated bucketfuls, weighing up to 50 pounds, were swung from a derrick and dipped into caldrons of boiling water and lye. The profitable prune trees were planted 108 to an acre, and each mature tree could yield 100 pounds of green fruit annually.

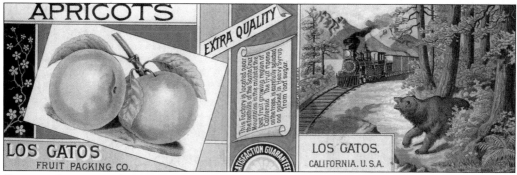

GOLDEN APRICOTS. Apricots grow to perfection in California, and that was especially true in the Santa Clara Valley. They were second in profit and acreage only to prunes. Mature trees would produce five tons to the acre. The small print on this Los Gatos Fruit Packing Company label reads, "This Factory is located near the foothills of the Santa Cruz Mountains in the midst of the best fruit growing region of California. The Fruit ripens on the trees, is carefully selected and packed in Heavy Syrup from loaf sugar." The canneries were in operation each year from about July 1 until October 1 and could run for up to 90 hours a week during the high season. On one busy Saturday in 1899, the Los Gatos Canning Company put up 54,000 cans of 'cots.

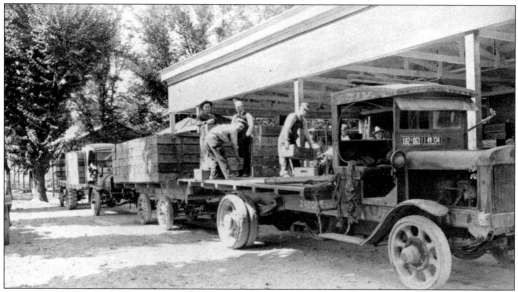

UNLOADING FRESH FRUIT AT THE CANNERY. Santa Clara Valley was said to be a place where "ten million fruit trees blossom in the spring, a sight that cannot be described." For the year ending August 1, 1907, Los Gatos exported 4,394,000 pounds of dried fruits and 2,152,000 pounds of canned fruits. The Los Gatos Canning Company was established in 1882 at 57 North Santa Cruz Avenue, in the area where the movie theater stands today, to serve the burgeoning number of local orchardists. The company was purchased by George Hooke in 1894. In 1900 "a very imposing front" was erected at the Santa Cruz Avenue entrance to the cannery. This was dubbed The Pavilion and provided seats for 450 people. It had electric lights and was to be used for meetings and "discriminating" entertainment. In 1906 Hunt Brothers purchased the cannery and in 1907 moved operations to what became known as "Cannery Corner," at North Santa Cruz Avenue and Saratoga Avenue, where it was in business until 1955. Hunt Brothers had a cannery cafeteria and a "kindergarten department" to provide child care. (Courtesy of the Museums of Los Gatos.)

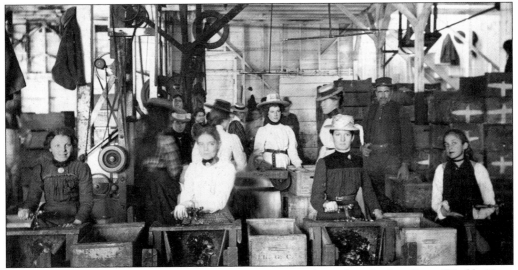

PITTING CLINGSTONE PEACHES. An August 15, 1890, editorial in the *Los Gatos Weekly News* states that in the cannery, "the labor is exclusively that which is not in demand in other business, women, boys and girls. This makes the cannery so much more valuable." The article advises that "when the fruit comes with a rush, let no person leave his post for a pleasure trip or a trivial cause." The writer also notes that "the Cannery, though run by San Francisco capital, has not employed Chinese. The fruit is handled entirely by white labor." One 14-year-old girl reports that she could make $1 a day, "when I work till twelve o'clock at night." During World War II, urgent calls were made for students and adults to make a contribution to the war effort by harvesting fruit and working in the canneries. When the cannery buildings were torn down in 1955, they were replaced by the Little Village shops and offices. (Courtesy of the Museums of Los Gatos.)

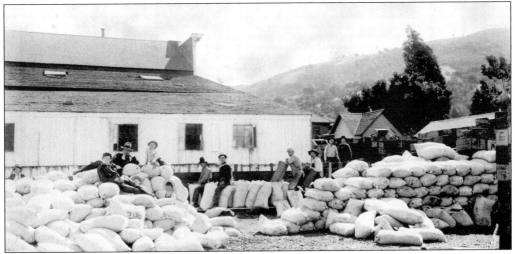

SACKING APRICOT PITS. The apricot pit industry was located in the Vasona Park area and operated by the Sewall S. Brown Company. Apricot pits were dried in the open, then taken by a conveyor system into the plant for cracking. The kernels were sent to Europe, where they were used in the manufacture of almond and apricot kernel paste, which was used in cakes, candies, and cookies. In 1931, the apricot pit brought the grower as much money per ton as did the ripe fruit. (Courtesy of the Museums of Los Gatos.)

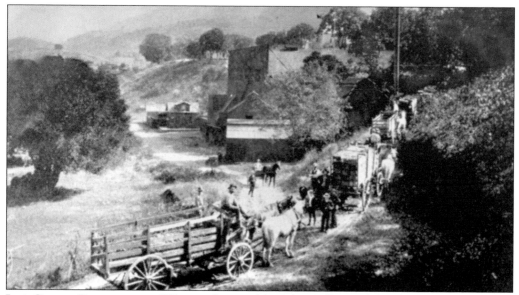

LOS GATOS COOPERATIVE WINERY. Initiated by John Cilker and built in 1886 at a cost of $50,000, this business purchased the grapes of its stockholders and other growers, manufactured wine, and sold it at wholesale prices. The winery processed 3,000 tons of grapes annually, producing from 450,000 to 500,000 gallons of wine in a year, along with quantities of brandy, port, and sherry. The goal was to produce wine of "standard quality." The grapes used were almost exclusively from nearby vineyards, many in the mountains. In this photograph, teams are pulling wagons to the upper level of the winery, where boxes of grapes were dumped into fermentation tanks, with the liquid allowed to run into tanks at the lower level. W.B. Rankin was secretary and manager. This property was purchased by town trustees April 24, 1913, and was the setting for the Los Gatos Pageants, which ran most years between 1919 and 1947.

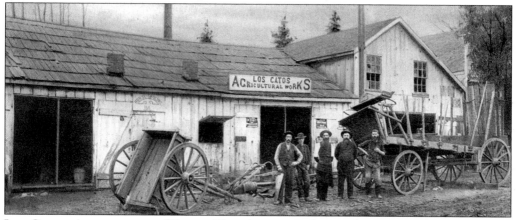

LOS GATOS AGRICULTURAL WORKS. This photo was taken in the 1870s and was part of the Clarence F. Hamsher collection, given to Los Gatos Library in 1956. These buildings were located on the north side of East Main Street, across from the current Civic Center. They burned down in 1890 in a fire that also destroyed the Seanor Opera House next door. According to the 1928 recollection of James Pearce, the men in front of the Agricultural Works, left to right, are John Erickson, Harry Ball, George Seanor, Charles Erickson, and young James Pearce. Mr. Pearce recalled the flood of 1871, when the Main Street bridge went out and he had to be pulled across the creek in a swinging basket.

"POULTRY PAYS WELL HERE." An undated Los Gatos Chamber of Commerce booklet states: "Those who have gone into the poultry business are making a great success of it, for the Los Gatos hen is a prize winner. There is no place where the chicks grow faster, or the hens lay more eggs." Beekeeping was another good way to make a living.

JOHN BEAN (1821–1909), INVENTOR. John Bean was already an accomplished inventor when he came to Los Gatos in 1883. He was 62, suffering from tuberculosis, and hoped to improve his health. He purchased a ten-acre almond grove and settled in, planning to live out his final years in comfort. He soon discovered that his trees had "San Jose scale," and in response he invented an effective continuous-action spray pump for insecticide. From sprayers to pumps to engines to plows to clothes washers—by 1928 John Bean products were found throughout the country. In 1928, the John Bean Manufacturing Company merged with the Anderson-Barngrover Manufacturing Company to become Food Machinery Corporation, or simply FMC. This undated photo of the Bean family includes John Bean at left and his wife Emeline Mary Edgecomb Bean (1829–1907) at center. Married in 1848, the couple is shown here surrounded by their adult children, Nettie Bean Gober (1868–1921), Roscoe Bean (1849–?), and Addie Maria Bean Crummey (1854–1915). (Courtesy of the Sourisseau Academy.)

BEFORE BECKWITH. These buildings, located at 27 to 35 East Main Street, housed the first retail store in Los Gatos, built in 1863 by Dr. W.S. McMurtry and J.Y. McMillan. Old Blackhawk was the name of a faithful delivery horse. The International Order of Odd Fellows occupied the top floor. The fire of 1891 destroyed this section of East Main Street, and Nathan Beckwith, a real estate developer, contracted with C.F. Scammon in 1892 to rebuild, this time with brick, at a cost of $16,250. During this era a lady might arrive in her carriage "drawn by a span with a coachman at the lines," and she would be served without stepping from her conveyance.

BECKWITH BLOCK. In 1895 the Beckwith Block housed the Scofield and Beach confectionery shop, which featured marble top tables, a Brussels carpet on the floor, and "mirrors by the dozen" on the walls. The soda fountain, done in black onyx and green mottled Italian marble, was trimmed with red marble and set on a slab of fawn-colored Tennessee stone. Thirty different flavors of syrups were offered. For much of its existence, the Beckwith Block served as the Rex Hotel.

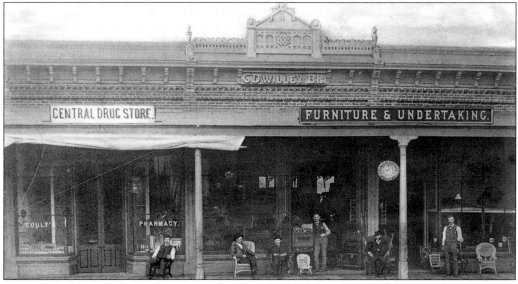

THE PLACE FAMILY ENTERPRISES. Three generations of men in the Place family played important roles in the business of the town. Alexander F. Place founded a furniture business in 1884. "Place Your Orders With Place," read the ads. Alexander's son Elvert E. Place (1863–1937), founded an undertaking business, which was combined with his father's enterprise. This pairing of services was not uncommon in the 19th century, and included the building of wooden coffins. George B. Place joined his father in business in 1910. This photo was taken after 1887, when the business relocated to the Willey Block on the north side of East Main Street, and before 1891, when the Willey Block was destroyed by fire.

THE PLACE WAGON. Pictured *c.* 1914, this wagon was built to accommodate either furniture or coffins. Hundreds of people came to Los Gatos for their health, particularly those with consumption (tuberculosis). Sanitariums were numerous. The influx of ill people also resulted in more deaths than would be usual in a small town.

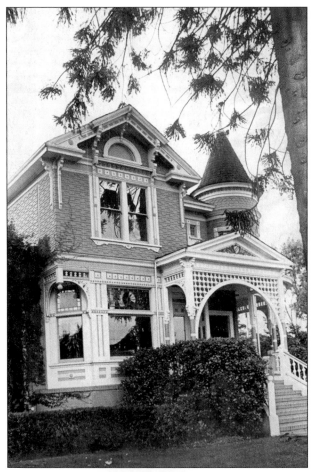

THE COGGESHALL HOUSE. Located at 115 North Santa Cruz Avenue, this classic Queen Anne structure was built by J.J. Hill in 1891 as the home of Mary G. Coggeshall, a native of Australia. From 1917 to 1971, it served as the Place Funeral Home, operated first by E.E. Place, and then by George Place, the son and grandson (respectively) of Alexander Place. The Coggeshall house is the last of a string of elegant homes that lined the west side of the street for half a century, from Bean Avenue to Saratoga Avenue. In recent years this house served as a restaurant.

EARLY MARKET. Edward C. Yucco was one of a series of owners of the Los Gatos Meat Market, founded in 1883 on East Main Street at Wilcox (College Avenue). This photo is dated 1889. Next door is F.L. Taylor, Architect, Land and Acres. A rain barrel sits on the wooden sidewalk.

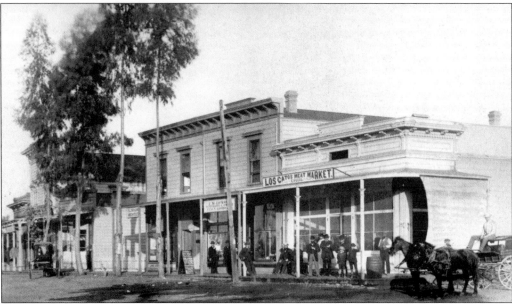

EARLY BUSINESSMAN. Edward C. Yocco (1857–1902), is pictured c. 1900. In addition to owning the Los Gatos Meat Market, Mr. Yocco served as a member of the school trustees in 1891, when the first group of Los Gatos students took the "post-graduate" course following grammar school. He also served as a director of the first permanent board of trade in 1895, and he was secretary-treasurer of the Los Gatos Cemetery Association. The Yocco barn was on Villa Avenue, near where the civic center is currently located. Edward Yocco died in the 1902 typhoid epidemic. (Courtesy of the Museums of Los Gatos.)

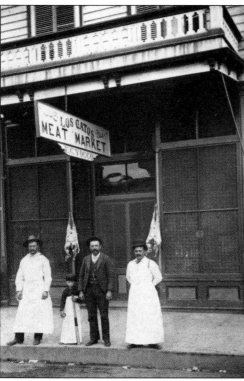

"PRICES TO SUIT THE TIMES." In 1891, Ed Yocco moved the meat market to the east side of Santa Cruz Avenue, a little north of Main Street. He advertised "beef, mutton, bacon and lard" at a fair price. He is pictured here, third from left, next to his young son, who sports a large apron and holds his baseball bat. Animal carcasses hang by hooks near the entrance to the market. (Courtesy of the Museums of Los Gatos.)

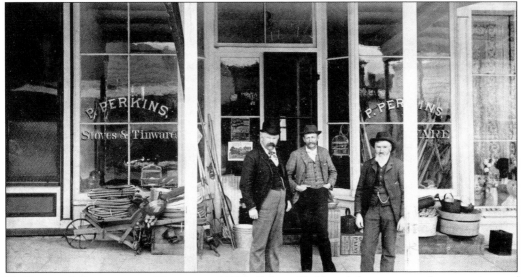

P. Perkins' Stoves and Tinware, 1886. Palmer Perkins, left, was one of a committee of twelve that fixed the boundaries of the town before incorporation. He was also elected a town trustee following the 1887 incorporation and served as the first chairman of the board or mayor. One of his newspaper ads at the time reads, "Perkins and Company sell Perfect Pure Phoenix Paint." This building, located at 23 East Main Street, remained Perkins Hardware until 1887. The man at center is Mr. Sweeney. William L. Lingley, right, was born in Maine in 1831. As a young man he was a sailor and served in the Civil War. He came to Los Gatos in 1880.

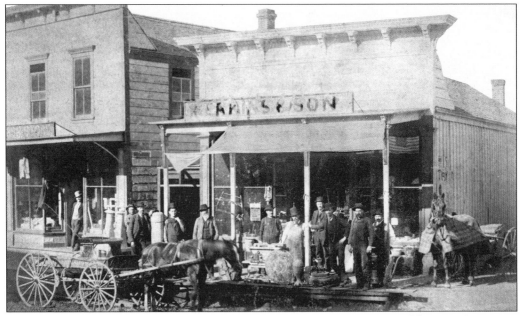

Lewis and Son, Stoves, Plumbing and Tinware. Mr. O. Lewis and his son George R. Lewis purchased Palmer Perkins' store and set up business as "Lewis and Son, Stoves, Plumbing and Tinware" in 1887. Lewis and Son was the first plumbing establishment in Los Gatos. George R. Lewis was a town councilman and active in the local Presbyterian Church for 55 years. This building narrowly escaped the fire of 1891, only to be gutted by fire in 1943.

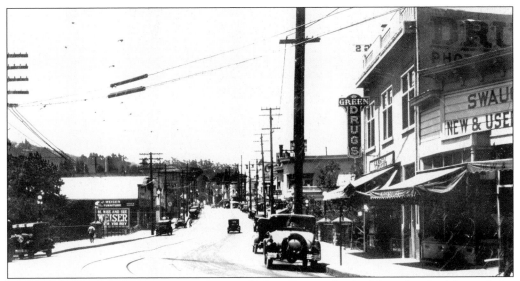

GREEN DRUGS. In this rare *c.* 1930 view of Main Street, the building that had housed the businesses of Palmer Perkins and George R. Lewis has become a secondhand store. It now fits snugly up against Green's Pharmacy "at the bridge." George A. Green founded his business in 1893 and moved to this location at 11 East Main Street in 1914. He remained there for more than 40 years, his establishment becoming a Los Gatos landmark. Mr. Green served on the town council (1922–1942), on the first planning commission (1924), and as mayor 1926–1927.

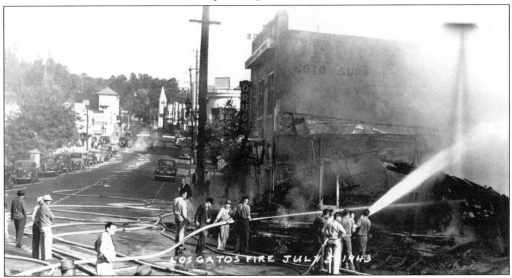

JULY 5, 1943. The fourth of July, 1943, was quiet in Los Gatos, during war time. But the next morning brought the biggest conflagration the town had seen since the great fire of 1901. A three-alarm fire on the north side of East Main Street leveled two buildings and damaged the red brick Rex Hotel (Beckwith Block) nearby, burning part of the same area destroyed by the 1891 fire. The flames broke out in the basement of the John E. Goode secondhand store, soon enveloped the entire building, and spread rapidly eastward. The original P. Perkins Stoves and Tinware building had been spared in 1891, but burned to the ground in 1943. Fireman Ralph Fanning was injured when he drove an axe into his foot while cutting a hole through the roof of one of the buildings. (Courtesy of the Museums of Los Gatos.)

HOME DELIVERY. For many years housewives called the local drugstore or grocery, placed their orders, and had their purchases quickly delivered to their homes. Notice that to call Green's Pharmacy a customer would simply "Phone 9." Drs. F.W. Knowles and R.P. Gober had offices on the second floor of the drug store and could be reached by phoning 2 or 3, respectively. Pharmacist Fred Callis, who purchased the business in 1946, is at the wheel of the Crosley. (Courtesy of the Museums of Los Gatos.)

LOS GATOS PHARMACY. W. John Whisenant came to Los Gatos in the early 1920s and purchased this 19th century building located at 45 East Main Street. He was a Main Street pharmacist, merchant, and real estate agent for many years and was appointed postmaster in 1942. In 1933 the building was purchased by pharmacists Clyde Kirkendall and William Vowels. Olivia de Havilland remembered going to "Kirk and Bill's" soda fountain for cherry cokes and 15¢ sundaes during her senior year at Los Gatos High School. When the famous star returned to Los Gatos in 1952 to give a talk at the high school, she cheerfully paid the 35¢ she had left "on the books" during her high school days. (Courtesy of the Museums of Los Gatos.)

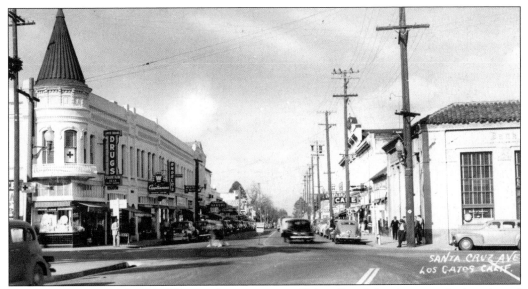

THE CORNER DRUG STORE. The northwest corner of "the elbow" first became the location of a drug store *c.* 1880. The Hofstra Block, now the La Canada Building, was constructed on that site in 1894, and for nearly 100 years the tradition continued, with pharmacists dispensing prescriptions under the "witch's hat" turret. Located at No. 1 North Santa Cruz Avenue and equipped with a marble-topped soda fountain, the store had become a social center by the 1920s, and the place to buy penny candies lined up in glass jars. In the early days, the shoeshine had his stand on the corner, and the Interurban electric streetcar stopped right in front. The town policeman on duty could often be found standing on this corner. Watkins-Shinkle was the first occupant of the Hofstra Block, and by 1924 the store was Comper and Burtner. Dr. Horace G. Jones had his office upstairs for more than 50 years.

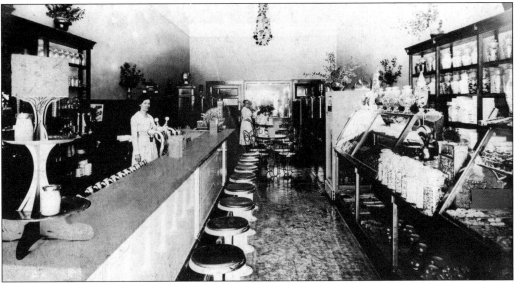

SWEET MEMORIES. Caldwell's "Sweet Shop," shown *c.* 1920, was located at 39 North Santa Cruz Avenue next to the cinema. This shop featured a long marble counter and stools, a glass cabinet, and shelves loaded with candies. Toward the back were booths where meals were served. The Caldwells lived in an apartment over the shop. (Courtesy of the Museums of Los Gatos.)

WOODHAMS' CARRIAGE SHOP ON EAST MAIN STREET, 1894. Studebaker Brothers Manufacturing Company had its beginnings in an Indiana blacksmith shop in 1852 and within 30 years was the largest wagon works in the country. In 1902 they began production of Studebaker motor cars. C.H. Woodhams carried the best wagons and buggies available at the time. An 1885 ad stated "Go to Woodhams' for anything in the harness line, at prices as low as the lowest in San Jose."

ROYAL SHAVING PARLORS. This early Los Gatos business was owned by Zephyr Macabee, second from left, later of gopher trap fame. The barber shop was situated in the Arlington Hotel, located on the north side of West Main Street next to the old bridge. A restaurant downstairs overlooked Los Gatos Creek. In 1909 Los Gatos barbers increased the price of a haircut to 35¢ and "razor honing" to 50¢, "prices to match the rest of California." The Arlington Hotel was destroyed in the fire of October 13, 1901. This photograph is c. 1895.

A BETTER TRAP. When his doctor advised him to obtain out-of-door employment, Zephyr A. Macabee gave up barbering and soon found his fortune in the invention and manufacture of the Macabee Gopher Trap. As John Bean had before him, he saw a need and met it. With gophers destroying orchard trees, using a pair of pliers, some wire, and a piece of metal, he produced a trap that was so effective it is still manufactured today. He obtained a patent for his trap in 1900. Simply constructed and easy to use, the green painted traps were manufactured at 110 Loma Alta Avenue, which was the Macabee home, built in 1895. The trap has undergone only minor changes since its invention. (Courtesy of the Museums of Los Gatos.)

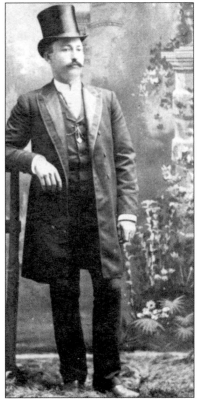

A.W. BOGART HARDWARE, 1906. This store was located at 14 North Santa Cruz Avenue. Lining the walls on the right are wash boards and buckets, buck saws, and, on the floor up front (perhaps indicating that winter was coming), portable kerosene stoves, pot bellied stoves, and to the far right, a wood stove—the kind that was often "polished-up" in households at this time. The men, from left to right, are A.W. Templeton, Andrew Bogart, Mr. Latham, and Charles Suydam. In 1909, Bogart's installed an elevator to utilize the second floor sales room. A.W. Templeman purchased the store from Bogart in 1916. (Courtesy of the Museums of Los Gatos.)

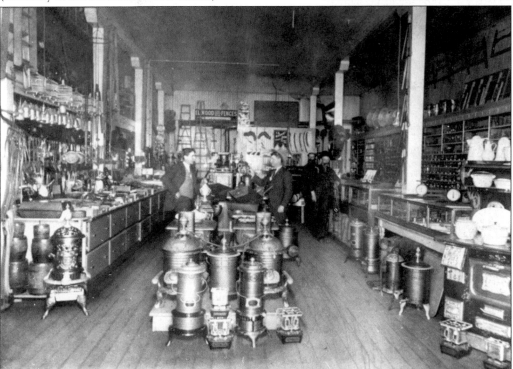

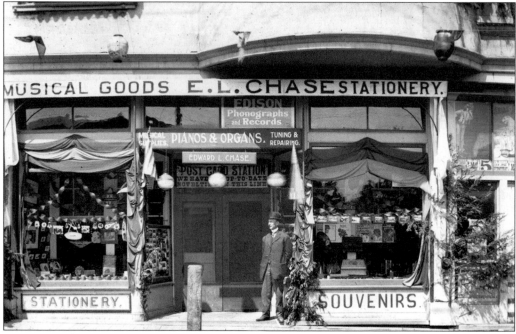

MUSIC MAN, C. 1908. When silent films arrived in Los Gatos *c.* 1900, E.L. Chase accompanied the moving pictures on the screen. His stationery and music store was located on West Main Street, "on the bridge" in the Montezuma Block. In addition to his post cards and writing utensils, he advertises "Edison Phonographs and Records," and "Pianos & Organs Tuned and Repaired." In the display window can be seen sheet music for two Albert Von Tilzer songs, "Good Evening, Caroline," and "Smarty." These songs were published in 1908, the same year Von Tilzer wrote "Take Me Out to the Ball Game." (Courtesy of the Museums of Los Gatos.)

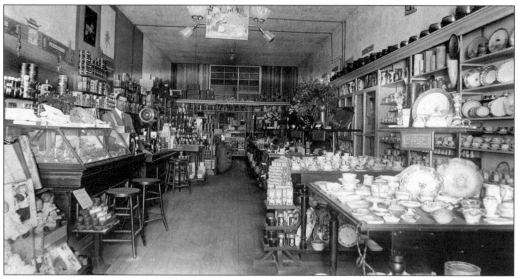

THE 20TH CENTURY TEA STORE. Located on the first floor of the Ford Opera House, this shop was owned by H.C. Baumgardner (1875–1965) from 1913 to 1919. Baumgardner, standing to the left in the photo, was the first Los Gatos telephone operator. He began work when an exchange was established at the rear of the corner drug store in the early 1890s.

H.J. Crall Company. Henry Jewett Crall (1845–1926) enlisted in the infantry at age 15 and was twice wounded in the Civil War. He married Hannah May Hausch on Dec. 30, 1890, and a month later the couple arrived in Los Gatos and opened Crall's "Palace of Sweets" at 120 West Main Street, the location of this photograph. This wooden building, located in the Aram Block, complete with wooden awnings, sidewalks, and hitching posts, was destroyed in the October 13, 1901 fire. At the age of 56, H.J. Crall started over again, moving his business to the Rex Hotel, then to the first floor of Ford's Opera House when it was completed in 1904. When Walter Crider bought the Opera House in 1916, Crall's moved to 21 North Santa Cruz Avenue, where it remained in business until 1981, operated by four generations of the Crall family.

Back in Business. An indefatigable H.J. Crall stands near the center in this photograph while he was a merchant on Main Street. On the right is a "loan library," where books rented for 10¢ a week. The post cards at left included Los Gatos scenes and books for sale included local writers Ruth Comfort Mitchell of Los Gatos and Saratogans Charles and Kathleen Norris. Henry C. Crall (1892–1978) took over the family business for his father in 1916, but the younger man was soon called to France during World War I. He returned to Los Gatos with a love for all things French. Henry C. Crall was a participant in the pageants for many years and authored the 1926 pageant, "Tashida."

FIRST NATIONAL BANK. The third bank in Los Gatos, the First National Bank was organized in 1911. This Renaissance Revival building at 160 West Main Street was constructed in 1920 and served as a bank until 1955. In 1927 Clarence F. Hamsher was elected president of the bank. Mr. Hamsher was also an avid local historian, and it was his collection of photographs, which hung in this building, that were donated to the Los Gatos Library in 1955. At the far left, the Southern Pacific right-of-way occupies land now dedicated to parking. Since the closure of the bank, this building has housed a number of restaurants.

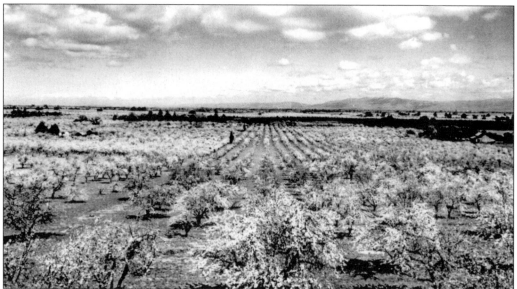

VALLEY DRESSED IN WHITE, 1952. This photo was taken from Blossom Hill Road, looking south. It was a beautiful spring day, with blossoms as far as the eye can see. The opening into the Santa Cruz Mountains, sometimes called the "Los Gatos Gap," can be seen in the distance. The photo was taken by Los Gatan Morton Harvey (1886–1975), a well-known vaudevillian and photographer. (Courtesy of Bruce Franks.)

Four

WIRES, TIRES, ROADS, AND RAILS

The only time a horse gets scared on the road nowadays is when he meets another horse.
—Harry Oliver

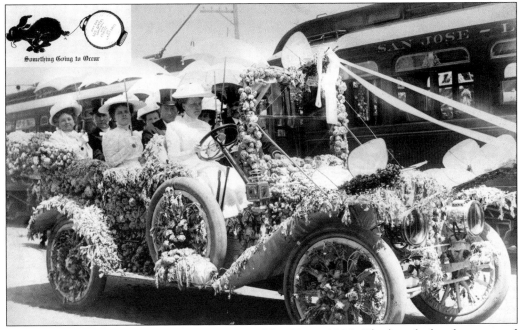

FLORAL CARNIVAL AND FEAST OF LANTERNS, MAY DAY, 1909. The board of trade sponsored this elaborate celebration, which featured a parade of flower-decorated carriages, automobiles, and bicycles. Silver cups were awarded in each division. Adorned with pink LaFrance roses, Mrs. J.R. Welch's 1908 Rambler won in the category of "Best Decorated Auto Driven by a Lady." The day's activities included a maypole dance at Bunker Hill Park and the "Baby Show Parade," where more than 300 "dear little darling dumplings" were wheeled down the street. Mr. Talbot of Santa Clara College sent up his balloon "Constantine," with a miniature flying machine attached. An "old-time Spanish luncheon" was served beneath the trees. During the evening, every home was illuminated with Japanese lanterns, and the Grand Ball was held at Hunt Brothers Cannery. (Courtesy of the California Room, San Jose Public Library.)

FIRST ELECTRIC LIGHT POLE. In early Los Gatos, the streets were dark and uneven, and sidewalks were scarce. The first electric lights were in operation at the Los Gatos Manufacturing Company building on January 31, 1891, and electric street lights were turned on June 24, 1896. Power for the street lights was generated and transmitted by the Hume Ranch on Glen Una Drive. The lamps were hung from "artistic brackets" over the center of the streets and were "comparatively free from the disagreeable sputter so frequent in electric lighting." When the lights came on, the town band "discoursed sweet music for an hour or more." The first electric light pole was erected on the north side of West Main Street, opposite Oak Street (later Front Street and now Montebello Way). The ornate towered building in the background was the Wilcox building, which housed the Commercial Bank until destroyed by the fire of 1901. Only the fireproof vault survived. The Wilcox Block was replaced by the Rankin Block in 1904.

LOS GATOS TELEPHONE COMPANY CABLE SPLICER, 1934. The telephone arrived in Los Gatos in the early 1890s, and by 1895 residents were subscribing for phone service. The Los Gatos Telephone Company, a hometown corporation, was organized November 10, 1910, with 326 subscribers. In 1925, the telephone directory listed more than 1,200 subscribers. Number service began in 1927, and "harmonic ringing" was a feature of the system by 1949. In the 1930s the telephone poles, which had originally arrived by train from Boulder Creek, were removed from the business district, replaced by underground cables.

UNHAPPY CUSTOMER, JULY 1, 1931. An ad for the Los Gatos Telephone Company in the 1938 directory promises that a telephone "Saves Time – Saves Strength – Increases Personal Effectiveness." However, they seem to have an unhappy customer in this classic black and white photo. Nevertheless, rural residents served by the company hoped to benefit from the company's pledge to be "Animated by the Spirit of Service." One resident of Call of the Wild hoped the Los Gatos company would improve upon his current situation where "My line is just a wire stretched between trees along the creek." Alice Matty of Wrights reported she used a megaphone between her house and store.

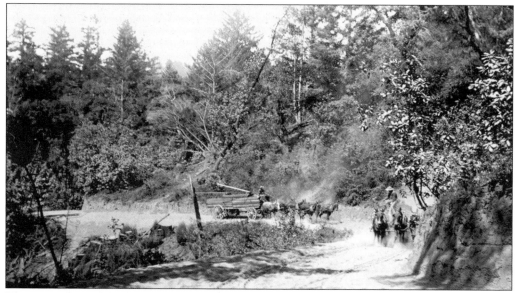

HISTORIC ROUTE. In the years following the establishment of Forbes Mill, Los Gatos village was a favorite stop for teamsters traveling the toll roads between Santa Cruz and San Jose. This winding transportation corridor through the mountains followed Indian trails along Los Gatos Creek, which later became six- to eight-foot-wide logging and stagecoach roadways. Eventually this same basic route evolved into Highway 17. (Courtesy of Clyde Arbuckle Collection, California Room, San Jose Public Library.)

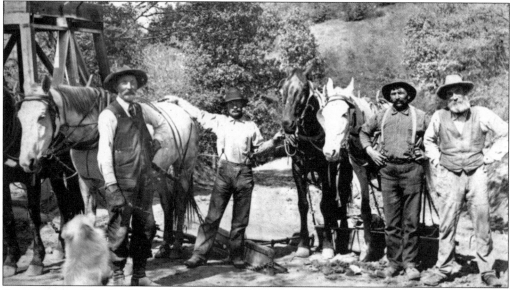

ROAD CREW. Charles H. Cook and his helpers maintained the old Santa Cruz Road to the summit in the early 1900s. The mountain route has always been preferable to going "around the horn" (via Watsonville and Gilroy) when traveling from the Santa Clara Valley to the coast. A 1903 county ordinance stated that no automobile was to travel on the Los Gatos–Santa Cruz Highway or the Mt. Hamilton Road above Alum Rock Park. The ruling was not effective, as more and more autos began to use the mountain roads. (Courtesy of the Museums of Los Gatos.)

SCENIC HIGHWAY. A California State bond measure in 1911 resulted in the construction of a 16-foot-wide Portland Cement circuitous highway over the mountains, completed in 1921 at a cost of $39,000 per mile. Approximately 8,000 automobiles passed over the new highway the first Sunday it was open. Before long, Sunday afternoons would find traffic returning from the coast backed up five miles south of Los Gatos, unable to move, despite this idyllic picture postcard view.

TRAFFIC! NEAR ALMA, 1926. Even though the road "over the hill" became very busy soon after it was paved, it was still a great improvement over the dirt and gravel road that preceded it. Although town roads, as well as the roads to San Jose and Saratoga, were kept sprinkled by a horse-drawn water wagon to keep down the dust beginning as early as 1891, many people remarked that driving on cement was so much cleaner that it was a godsend. However, then as now, more than one automobile went over the side of the narrow twisting artery. (Courtesy of the John Baggerly Collection, *Los Gatos Weekly Times*.)

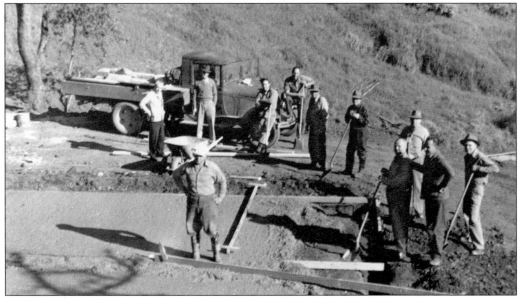

ROAD CONSTRUCTION, 1930S. A July 1937 report recorded traffic counts in Los Gatos at 14,000 autos in 16 hours. Research by the Santa Cruz Chamber of Commerce showed that "many persons of a timid nature have in recent years foresworn the use of the Los Gatos–Santa Cruz Highway because of its hazards." The decade of the 1930s saw contracts to upgrade most of the roadway to four lanes, with a surface width of 46 feet. The new bituminous macadam surfaced highway was built in several different sections and stages. *California Highways and Public Works* reported that "the number of curves has been reduced by 130, to a total of only 22; 6101 degrees of curvature, or nearly the equivalent of 17 complete circles have been eliminated."

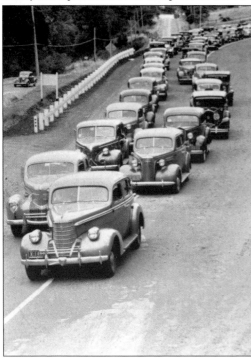

JULY 5, 1939. This photo was taken by the *San Jose Mercury News* when "splendid Highway 17" was opened 1.8 miles south of Los Gatos, near today's Lexington Reservoir. Old Santa Cruz Highway is on the left, the new highway on the right. Until this upgrading of the highway, the most popular way to travel from Los Gatos to Santa Cruz had been on the "Suntan Special" train, which ran until 1940, when severe winter storms damaged the tracks and tunnels and service was discontinued. (Courtesy of the John Baggerly Collection, *Los Gatos Weekly Times.*)

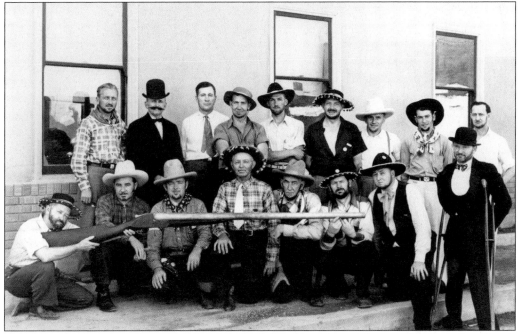

WHISKERINO CELEBRATION. On August 22, 1940, a three-day celebration began in Los Gatos, designated as "Trail Days." The occasion was the completion of the Los Gatos-Santa Cruz highway into town. Dedication ceremonies featured a parade of different modes of transportation through the years. Widening the last stretch of road in the narrow Cats' Canyon just south of town had been especially difficult due to the proximity of the railroad tracks and the steep terrain. This photo was taken on what is now Montebello Way, with the railroad station in the background. Many of the men let their beards grow to celebrate the event. Identified are Carl Hubbell on crutches, Raymond Fisher third from left in top row, and Paul Straub fourth from left in bottom row. (Courtesy of the Museums of Los Gatos.)

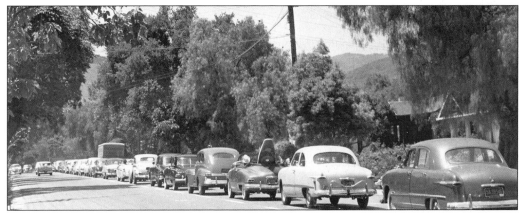

SANTA CRUZ BOUND, 1955. An "iron curtain of automobiles," all headed to the coast, divided Los Gatos on Memorial Day weekend, 1955. On warm summer days, traffic was often backed up for miles within town limits. Intersections were controlled by police, who were concerned that emergency vehicles wouldn't get through. It wasn't until 1957 that State Route 17 was completed to allow most traffic to bypass the town. Notice the Studebaker convertible with surfboard on board.

HIGHWAY 17, C. 1957. By the 1930s, automobiles were beginning to have a negative effect on the Southern Pacific Railroad's passenger and freight business, and a proposed "great dam" that would submerge the towns of Lexington and Alma started to be mentioned in the newspapers. The Lexington Dam project was completed in 1952, and soon the freeway would replace the beautiful shaded creek that meandered under the Main Street Bridge. Memorial Park, which once offered picnic grounds, an outdoor dance pavilion, the municipal swimming pool, and a gracious spot for holiday celebrations, was gone by 1954. In this photograph, Los Gatos Creek is confined to the concrete channel on the left, removed from its original location adjacent to Forbes Mill. The remains of the old mill can be seen at right, 25 feet from the freeway. (Courtesy of the Sourisseau Academy.)

BELOW THE MAIN STREET BRIDGE, C. 1920. Bunker Hill Park was made possible when W.C. Shore donated a portion of his picnic grounds, "Shore's Grove," as the nucleus for a public park. The park was dedicated on June 17, 1897, named in honor of the 122nd anniversary of the Battle of Bunker Hill in the American Revolution. Two thousand people arrived by train to celebrate. The Poet of the Sierras, Joaquin Miller, recited "Sail On," and Alfred Wilkie sang "The Sword of Bunker Hill." The park was enlarged and renamed Memorial Park in 1920. Some shed a tear in 1954 as they watched bulldozers knock down the massive oaks and sycamores that lined the creek, in preparation for the freeway. The town's World War I cannon was turned over to the "Salvage for Victory Drive" in 1942, the money used to buy comfort kits for soldiers overseas.

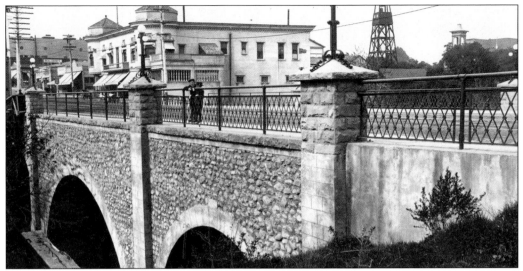

CONCRETE AND RUBBLE STONE BRIDGE. The *Los Gatos Weekly News*, of May 4, 1906, stated, "By a vote of 333 to 7 on the 5th of December, 1904, $20,000 in bonds were issued by the Town, and the San Jose Los Gatos Interurban Railway Company put $6,000 into the structure, and $1,600 more was realized as premium on bonds." Total cost for the bridge was $27,000 "in round numbers," and 3,500 barrels of cement and 6,500 yards of earth fill were used in construction. "The bridge was to have been dedicated Tuesday, May 1 (1906), by a barbecue and May Day celebration, but the big structure has to go without this formality on account of the earthquake which the bridge withstood without injury." The stone bridge stood until 1954, when it was removed in favor of Highway 17, requiring dynamite to bring it down. In the distance can be seen the fire bell and tower of the school building (1886–1922). A path under the west arch of the bridge led from the school to the park.

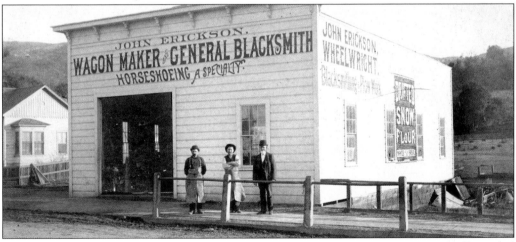

VILLAGE SMITHY. The blacksmith's shop was a gathering place for men and boys. Smoke curled from the forge and sparks flew when the hammer met metal. John Erickson, proprietor, came to Los Gatos in 1878. He is pictured here in the center; his employee George P. Brown is to the left, and "Mr. Bowman, an old timer," is to the right. The photo is *c.* 1895. This shop was located at 280 East Main Street, at the foot of El Monte Hill and opposite the El Monte Hotel. John Erickson advertised in the 1902 Los Gatos phone book, stating he was a "practical wheel wright and carriage maker. Fruit trucks of all kinds made to order." (Courtesy of the Museums of Los Gatos.)

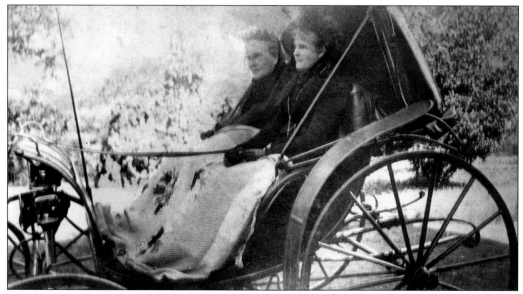

1888 Runabout. This photo was taken in front of the Lyndon Farwell home on Broadway, and shows Mrs. John Lyndon at right along with Mrs. Benjamin H. Mace, a poet who came to Los Gatos from Maine for her health. These two Victorian ladies are settled under a lap robe. Kerosene carriage lanterns and the whip can be seen in the photo. Unfortunately Los Gatos newspapers of the time are filled with stories of runaway horses, overturned wagons, serious injuries, and fatalities. The July 17, 1885, *Los Gatos Weekly News* recounts a recent episode of "horses and wagons flying in all directions" on Main Street. The results were as follows: "Number of runaways, three; men hurt, one; horses hurt, one; wagons more or less demolished, three." (Courtesy of John Baggerly collection, *Los Gatos Weekly Times*.)

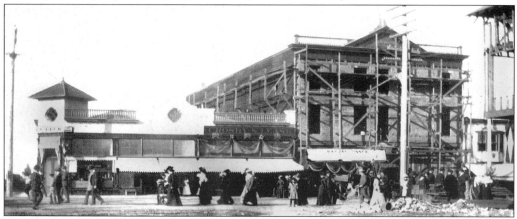

Ford Opera House, 1904. After the Seanor Opera House burned to the ground in 1890, and the beautiful Johnson Opera House, the "Pride of Los Gatos," suffered the same fate in 1894, plucky Los Gatos tried again. Ironically, the 1901 town fire cleared the way for the opera house that still stands today. Eugene Long Ford (1857–1909), the Southern Pacific station agent, bought the Parr property, the site of the burned "White House" department store, for $10. The Ford Opera House opened on October 10, 1904, with a performance by the Sweet Clover Company. Minstrel shows and melodrama by barnstorming troops of thespians, often with a discordant brass band in tow, were popular. A noon parade advertised the evening performance. At far right, the Rankin Building is also under construction.

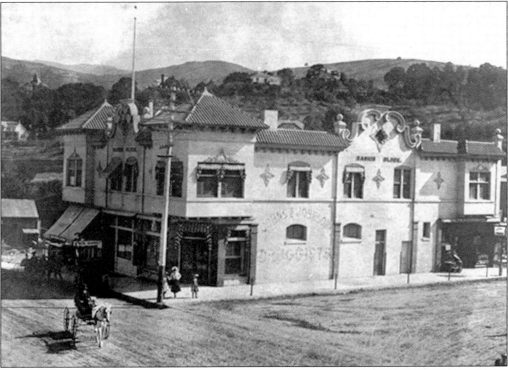

RANKIN BLOCK, 1904. After the Commercial Bank Building (Wilcox Block) burned to the ground in 1901, W.B. Rankin and his wife Clara had this Mission Revival–style building constructed on the site at Main and Front Street (now Montebello Way). The building still stands today, with the same corner entrance. Clara Rankin was the first female member of the local chamber of commerce. This building housed the post office from 1917 to 1948. Johns and Johnson Druggists were early tenants, and W.A. Pepper's Union Market is at the east end of the building. A row of hitching posts lines the wooden sidewalk. In the early days, wagon traffic used either side of the street.

CYCLIST, 1905. John A. Maciel of Los Gatos is pictured here dressed to ride his bicycle, wearing a high collar, tie with stick pin and clasp, boutonniere, watch fob, and straw hat—all coordinated with his four-button, single breasted suit with high lapels. The bicycle has a pant clip hanging from the bar, for his unpleated pants. The photo was taken by W.H. Hardy. (Courtesy of the Museums of Los Gatos.)

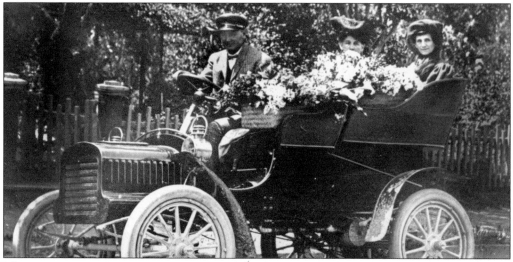

MOTORISTS, 1905. In 1899 an automobile first appeared on the streets of Los Gatos, representing a crossroads in time, from horse drawn to horseless transportation. Horses were known to rear in fright at the sound of the roaring, puffing early vehicles. In this photograph, Edgar F. Smith sits at the wheel of a 1905 Model C Ford, purchased for $950, FOB Dearborn, without top or windshield. The setting is Wilder Avenue, Los Gatos. (Courtesy of the Clyde Arbuckle Collection, California Room, San Jose Public Library.)

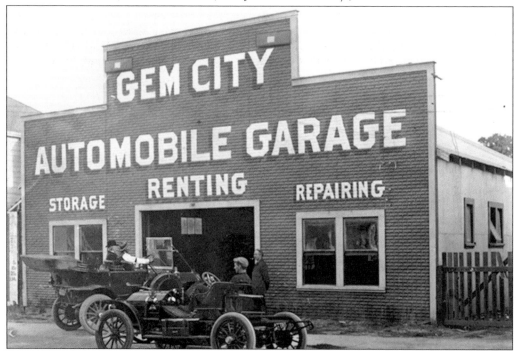

MAIN STREET, C. 1907. Righthand drive was common in early cars. Motorists were a hearty group who had to be prepared to patch and change two or three tires on a Sunday drive. J.D. Shore, town marshall from 1908 to 1912, "called down" people who ran automobiles faster than 10 miles per hour within the town limits. "This racing in Los Gatos will have to stop," he declared. The Gem City Garage was located on West Main Street, west of the Lyndon Hotel.

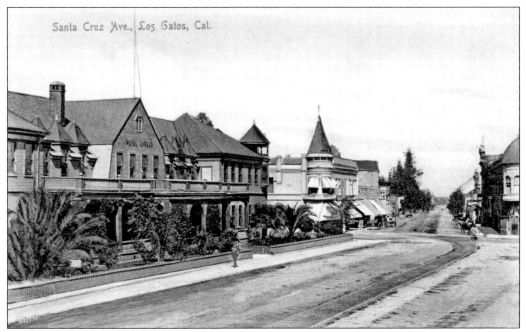

Santa Cruz Ave., Los Gatos, Cal.

TRIPLE TOWERS. This *c.* 1907 "postal" of Santa Cruz Avenue clearly shows the Interurban Railroad tracks that had been installed in 1904. The three towered buildings, from left to right, are the Hotel Lyndon (demolished 1963), the Hofstra Block (now La Canada, still standing), and the Theresa Block (demolished 1931). John Lyndon built the Theresa Block in 1890, and it was named for his first wife, who died in 1889. For many years the Theresa Block housed the Bank of Los Gatos. It was replaced by the handsome Bank of American building, used today for retail.

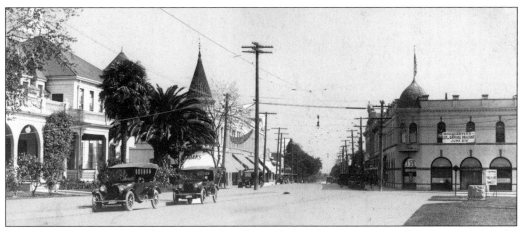

PROGRESS, C. 1920. In a photograph taken from almost the same spot as the previous one, the forward march of progress is evident, with the addition of power poles, pavement, curbs, gutters, street lights, and two Dodge touring cars parked in front of the Lyndon. The first streets paved, beginning in 1914, were San Jose Avenue (Los Gatos Boulevard), Main Street, and Saratoga Avenue. A banner on the Theresa Block advertises the annual pageant.

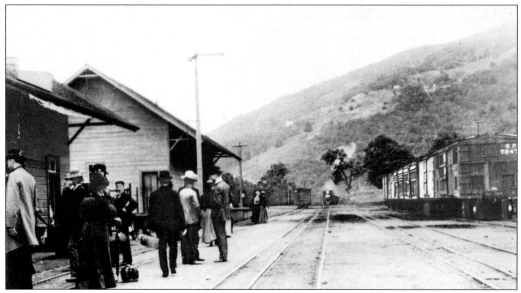

LOS GATOS WAS A RAILROAD TOWN. When train service to Santa Cruz resumed in 1909 after the 1906 earthquake, it was celebrated at every station along the way. The *Los Gatos Mail* reported, "At Los Gatos hundreds of people gathered at the depot upon arrival of every train; torpedoes were placed on the rails and added the noise of their explosion as the outgoing wheels smashed into them." Many Los Gatans headed down to the station in the evenings just to see the trains come in and to watch the steam locomotives take on water for the trip over the grade to Santa Cruz.

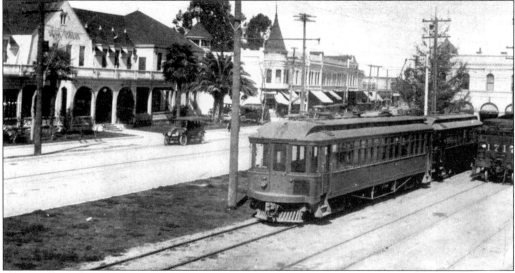

SAN JOSE–LOS GATOS INTERURBAN RAILWAY COMPANY. Despite interference from both the Southern Pacific and the San Jose Railroads, a new electric street car line was incorporated in 1903. In February 1904, twelve large green street cars arrived from the American Car Company in St. Louis. The interiors were finished in handsomely carved cherry, and the exteriors were eventually painted red. Each car sat 52 passengers. The gala first trip over the San Jose–Los Gatos line took place on March 19, 1904, ending with a festive banquet at the Lyndon Hotel. The Peninsular Railway, as it was called after 1909, linked Los Gatos to nearby towns and all the way to Palo Alto and Alum Rock Park. (Courtesy of William A. Wulf.)

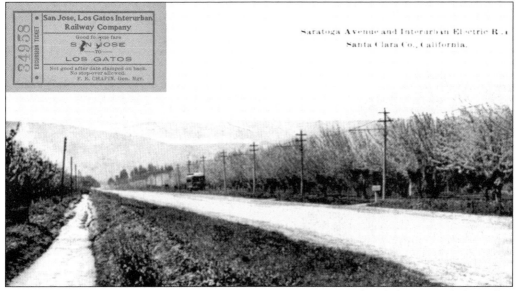

BLOSSOM TROLLEY TRIPS. In May 1910 special trips were introduced that toured the valley when the orchards were in full bloom and the wild flowers in brilliant array. The jaunt from Los Gatos to Saratoga was especially beautiful. Passengers were able to look out over a sea of blossoms to Lick Observatory atop Mt. Hamilton, 30 miles away. The trip cost $1. The Interurban cars ran on an hourly schedule, and with their 45 horsepower motors were guaranteed to do 30 mph on level track. They were an important part of life in Los Gatos until they were discontinued in 1933.

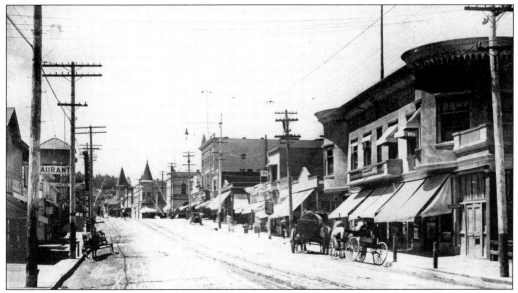

LOOKING WEST ON MAIN STREET, C. 1912. The building at right is the Montezuma Block, constructed in 1902 after the 1901 fire destroyed the Arlington Hotel on this site. This building, which still stands at 14 West Main Street, housed the post office from 1902 to 1917. In 1941, the building was converted to housing. An early automobile is seen parked in front of Ford's Opera House, but people crossing the dirt road would still need to step carefully around numerous "road apples," left by hundreds of horses.

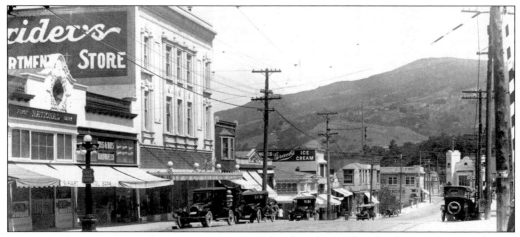

LOOKING EAST ON MAIN STREET, C. 1919. Within less than a decade, the appearance of Main Street has changed dramatically. The street is paved and automobiles have replaced horse-drawn vehicles. In 1916 J. Walter Crider purchased the Ford Opera House, and Crider's Department Store was soon prominently in place at that location, where it stayed until it closed in 1957. The upper floor no longer hosted the likes of cherub-faced Paloma Schramm, world famous child pianist who used a "contraption" to operate the pedals of the piano, as her legs were too short. The dancing classes and cotillions of Miss Ellis were no more. Instead, the space was used for furniture storage. Crider promoted his business with a number of novel advertising gimmicks, including hiring a midget Santa Claus one Christmas and in 1932 arranging for a "human fly" named "Babe" White to climb the face of the building during noon hour.

REDHEADED AVIATRIX, NETA SNOOK SOUTHERN (1896–1991). Neta Snook began flying lessons in 1917 and in January 1920 gave Amelia Earhart her first flying lesson in Neta's World War I Canuck training airplane. She charged Amelia 75¢ per minute for her first lessons. Neta's only instruments when she flew were an altimeter and a watch. She was the first female pilot to carry passengers and perform aerial stunts. In her later years, Neta retired to a small acreage in Los Gatos, and she began writing her memoirs in 1972, thanks in part to an adult education class at Los Gatos High School. Her book was titled *I Taught Amelia Earhart to Fly*. Neta died at the age of 95 in 1991, the same year she took her last airplane flight.

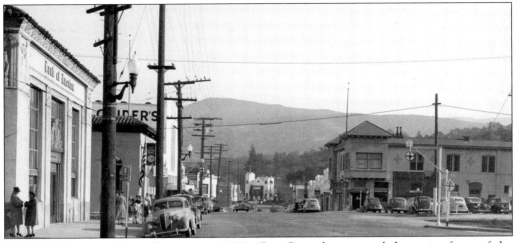

LOOKING EAST ON MAIN STREET, C. 1932. "Los Gatos has escaped the major force of the depression, both spiritually and commercially," declared Los Gatos Mayor I.D. Mabie in July 1931. "There are no vacant stores on Santa Cruz Avenue and few unoccupied houses . . ." Police officer Lyman Feathers set up "Hotel Feathers," which provided supper, bed, and breakfast for unemployed itinerants who arrived in town. Otherwise there was little unemployment and the summer tourist seasons were profitable. Massol, Tait, Wilder, Bean, and Nicholson were paved for the first time in 1931, at a cost of $57,000. The Works Progress Administration did contribute to employment in Los Gatos in the 1930s with projects such as installation of lights at the high school athletic field, book repair at the library and construction of a new playground. At far left is the new Art Deco Bank of America building

LOS GATOS LADIES, SEPTEMBER 10, 1931. Caroline E. Baggerly and Lura Whisenant are pictured at the home of John and Barbara Baggerly on Johnson Avenue in Los Gatos. The elegant automobile is a Cord L-29 sedan. Caroline's husband, Hiland Baggerly, worked for his brother-in-law, Fremont Older, on the San Francisco *Call* and *Bulletin* before buying the *San Jose News* and later the *Mail-News* in Los Gatos, which he owned until 1949. Caroline was society editor for both of her husband's newspapers. "Hy" and Caroline's adopted son John Baggerly was a beloved local newsman who died in 2002. The Whisenants owned and operated the Los Gatos Pharmacy. (Courtesy of the John Baggerly Collection, *Los Gatos Weekly Times*.)

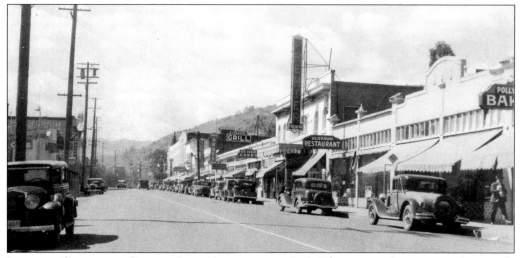

LOOKING SOUTH ON SANTA CRUZ AVENUE, C. 1935. This postcard view provides a walk down the street past Polly Prim Bakery at No. 55, Blossom Restaurant at No. 47, Premier Theatre at No. 41, Los Gatos Grill at No. 37, Duncan Drug at No. 31, Superior Bakery at No. 19, and Comper and Burtner Drugs at No. 1 North Santa Cruz Avenue. From 1882–1907, the Los Gatos Canning Company was located at No. 57, followed by Norton's Lumber Yard. The original movie theater, called the "Strand," was constructed in 1916. An extensive fire in 1929 resulted in the reconstructed art-deco styled "Premier."

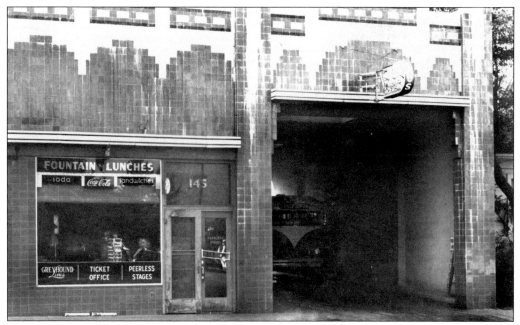

GREYHOUND LINES AND PEERLESS STAGES. The bus station was located at 145 North Santa Cruz, and is pictured here *c.* 1940. The bus was a popular way to travel to Santa Cruz or to commute from Los Gatos to San Jose or San Francisco. The depot served as a meeting place for local senior citizens, who gathered around the tiny lunch counter. (Courtesy of the Museums of Los Gatos.)

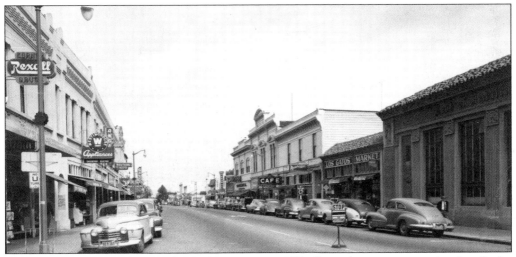

LOOKING NORTH ON SANTA CRUZ AVENUE, C. 1950. By mid-century it was hard to find a parking place. On the left, the Corner Drug Store is at No. 1, Davenport Electric at No. 5, Angelo's Coffee Shop at No. 7, Western Auto at No. 11, IOOF Hall at No. 15, Dan's Bakeshop at No. 19, and Los Gatos Theater at No. 41. On the right, at No. 2 North Santa Cruz Avenue, the Theresa Block has been replaced by the Park Vista Building (Bank of America). The Los Gatos Market was established in 1890 and had several locations, including this one at No. 8, North Santa Cruz Avenue. The 1890 Masonic Hall, with its high cornice, stands just down the street. It originally served as the Farmers' Union Building.

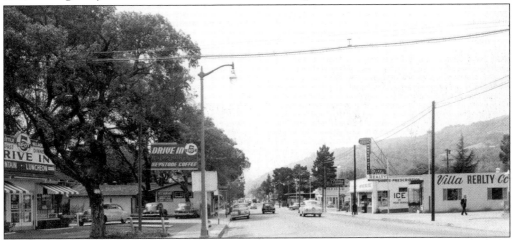

"CANNERY CORNER." Oak-sheltered burial grounds for Los Gatos were established in the 1850s at the southeast corner of Santa Cruz Avenue and Highway 9, known then as Cemetery Lane. By 1889 the old cemetery was filled, and a new cemetery was established on Los Gatos–Almaden Road. Bodies were moved to the new cemetery starting in 1890, but only if someone was willing to bear the expense. No one stepped forward to move "Little Willie Turner," age three, and so his remains, along with others, are now under asphalt. After most of the graves had been moved, this plot of land was used for cottages for the laborers who worked at the Hunt Brothers Cannery, located on the northeast corner of the intersection from 1907 to 1955. The 5-Spot Drive-In opened in the late 1930s, with Barbara Gibson Baggerly hired as the first waitress. After the 5-Spot was torn down in the 1950s, realtor Effie Walton created "Little Village" on the site, which remains today.

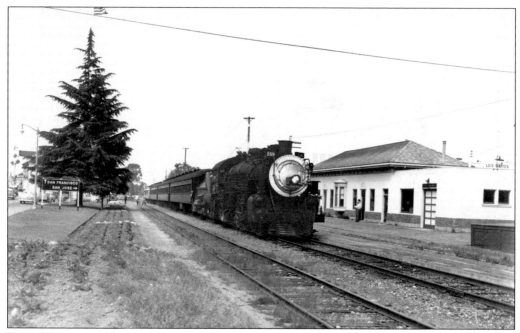

LAST SATURDAY TRAIN. The railroad was central to life in Los Gatos for more than 80 years. Business began to decrease when buses, automobiles, and trucks became more common. The poorly patronized line between Los Gatos and Santa Cruz ceased in 1940, and Los Gatos became the terminal. This photograph of the last Saturday commuter train was taken in April 1953. All service ended in January 1959, with the ceremonial pulling of a spike. (Courtesy of the John Baggerly Collection, *Los Gatos Weekly Times*.)

END OF AN ERA. The railroad tracks were pulled up in 1959, the Hotel Lyndon demolished in 1963, and the train depot in 1964. It was the late 1960s, and a new era had already begun.

Five

CULTURAL MEMORY

When I pass the Golden Gateway,
Hoping dear ones there to greet,
I shall find I'm in Los Gatos—
Ever calm and fair and sweet.

RUTH COMFORT MITCHELL YOUNG (1882–1954). Best known for her novel *Of Human Kindness*, which she wrote as a counterpoint to John Steinbeck's *The Grapes of Wrath*, Ruth Comfort Mitchell was a successful playwright, novelist, poet, and short story writer. Her first poem was published in *The Los Gatos Mail* when she was fourteen. As she notes at the bottom of this photograph, c. 1920, her pets are lined up according to age—Gow Moy, the deer Lo Lo Mi, Beaver Dick, and Trek, The Gentleman Dog.

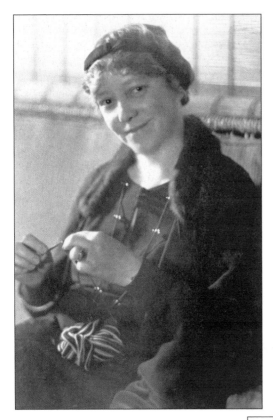

LADY IN GREEN. "I yield to no one in my devotion to Los Gatos," Ruth Comfort Mitchell wrote to Lloyd E. Smith, editor of the *Los Gatos Times* in 1952. "I came here first at the wide-eyed age of four, by train and under convoy of my distinguished Uncle Joel Bacon Low, who wore a high black topper. I was going to the country from San Francisco streets!" She recalled being conveyed by horse and buggy "to the grandparents' house, Diamond Cottage, at the top of Johnson Avenue." She wore tasseled high-buttoned bronze boots, and later in her life was known for always wearing green. She was a member of the Christian Science Church of Los Gatos, an active participant and author of the Los Gatos pageants, a member of the Los Gatos Daughters of the American Revolution and the History Club of Los Gatos. For eight years she served as Republican national committeewoman from California. She died in her bathtub of heart failure in 1954. (Courtesy of the Museums of Los Gatos.)

SANBORN YOUNG (1873–1964). Elected a California state senator in 1925, Sanborn Young served two terms from his home district. Mutual friends introduced him to Ruth, and they married in 1914 at the Grand Canyon. While serving in the Senate, he introduced a bill to abolish saw-tooth animal traps, which was enacted in 1929. In 1931, President Herbert Hoover appointed Young as a delegate to the International Conference for the Limitation of the Manufacture of Drugs, in Geneva, Switzerland. Sanborn and Ruth sailed to Europe to attend "the opium conference." They both enjoyed trail riding, and several times ventured as far south as Big Sur. (Courtesy of the Museums of Los Gatos.)

YUNG SEE SAN FONG HOUSE.
Nestled in the hills of Los Gatos, the Young's home was completed in 1917 on land given to the couple by Ruth's parents. The elaborate Chinese-styled home was the center of a self-sustaining farm where vegetables and poultry were raised. Visitors included U.S. Sen. James Phelan from nearby Villa Montalvo, movie stars Joan and Constance Bennett, and President and Mrs. Herbert Hoover. A phrase from Ruth's prose, "A kerosene moon in a cambric sky," may capture the ethereal mood of this photograph by Mrs. M.R. Lasley. The house on Cypress Way was painted green with Chinese Red trim and was photographed after snow fell in Los Gatos in 1932. (Courtesy of the Museums of Los Gatos.)

MONTE PARAISO. In 1880, writer Josephine McCrackin (1838–1920) purchased 26 acres of land for $540 from Lyman Burrell, for a ranch on Summit Ridge. She lived there for a quarter century, writing newspaper articles and short stories for many publications, including the *Overland Monthly* and the local *Mountain Echoes.* Visitors to her salon, located near "Call of the Wild," included literary giants Bret Harte, Ambrose Bierce, and Mark Twain. This undated photo shows Josephine McCrackin on the right, with Zasu Pitts. After a devastating fire destroyed her home and its surrounding redwoods in 1899, she and Andrew P. Hill founded the Sempervirens Club. (Courtesy of the History Archives, Museum of Art and History, at the McPherson Center, Santa Cruz, California.)

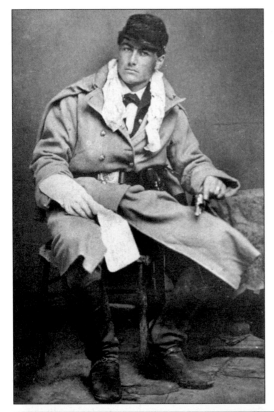

COL. CHARLES ERSKINE SCOTT WOOD (1852–1944). An 1874 graduate of West Point, C.E.S. Wood was a soldier, poet, painter, attorney, satirist, socialist, pacifist, and bon vivant—a paradox, a patrician Democrat. As a young Army lieutenant in Washington Territory in 1877, he took part in the campaign against the Nez Pierce Indian tribe led by Chief Joseph, a tragic episode in American history. It was Wood who recorded Chief Joseph's famous words of surrender, "I will fight no more forever!" Wood later said that Joseph "cannot accuse the United States government of one single act of justice." The two men became friends in later life and even "traded sons" for a summer. Attorney Wood's varied clients included Margaret Sanger, an advocate of free speech and birth control; anarchist Emma Goldman; and James J. Hill, railroad tycoon and "Empire Builder."

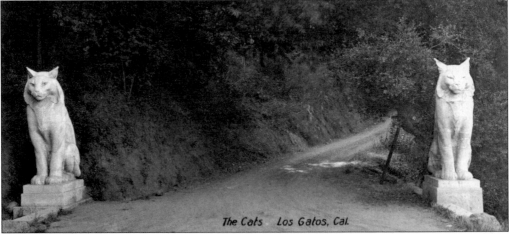

The Cats Los Gatos, Cal.

THE CATS. In 1919 C.E.S. Wood and the woman who became his second wife, poet Sara Bard Field, discovered 34 acres of wooded hillside just south of Los Gatos. At first the couple spent time on the property in a small shack, cooking in a stone fireplace, reading to each other, and enjoying the country retreat. After spending time in Europe, they decided to make Los Gatos their home, and their house at The Cats estate was completed in 1925. Sculptures by Robert Stackpole and Benny Bufano enhanced the estate, and "To Poetry" was hardened in cement on the kitchen wall. The colossal cats were sculpted in 1922 by Robert Trent Paine and took a year to complete. Colonel Wood considered them "a sort of missionary work in culture in California," and he refused to move them off the road, even when they were vandalized on several occasions.

EXTRAORDINARY LIVES. Pictured at left is Sara Bard Field (1882–1974), who in 1915 crossed the country in an Overland automobile, an unheard-of adventure, to deliver almost a half million signatures in support of women's suffrage to President Woodrow Wilson. The trip took 88 days over mostly unmarked, unpaved roads. In this *c.* 1925 photo, she stands arm-in-arm with her future husband. At the center of the photo is Henry Meade Bland (1863–1931), poet laureate of California (1929–1931), who grew up on a small farm in north Los Gatos. Dr. Bland served as the first principal at Los Gatos High School when it was located at the University Avenue Central School and later taught at San Jose Normal School. Second from right is legendary tennis champion Helen Wills Moody (1905–1998), winner of two Olympic gold medals. Sen. James Duval Phelan (1861–1930) sits at far right, three-time mayor of San Francisco and builder of nearby Montalvo. The Woods entertained the literati of their day at The Cats, including Lincoln Steffens, Robinson Jeffers, Fremont Older, William Rose Benet, Yehudi Menuhin, and Clarence Darrow. Colonel Wood counted Mark Twain and Ansel Adams among his friends.

LAWRENCE TENNEY STEVENS MONUMENT. In 1924 in Sorrento, Italy, Erskine and Sara met the American sculptor who in 1934 would carve their likenesses from a three-ton block of French limestone. The memorial is about seven feet high and four feet square, and is meant to celebrate and commemorate the love and fire of their happy years together at The Cats. Sara's words to Erskine were, "Had we not clutched love flying by, Where had you been, Where had I?"

JACK LONDON (1876–1916) AND HARRY RYAN (1875–1957). A prolific author who died at the age of 40, London's adventure stories, many set in Alaska where he spent years searching for gold in the Klondike, have become American classics. London's friend Harry Ryan named his 140 acre mountain ranch, a mile west of Holy City, "The Call of the Wild" after London's famous novel. Ryan (at right), who met London when both were fighting for trade unions, was proud of being arrested with London 22 times, 3 times in one night. While in Los Gatos in 1898, London lived at the home of Ruby Howes near the corner of Union Avenue and Los Gatos–Almaden Road, where he carved his initials in the door frame.

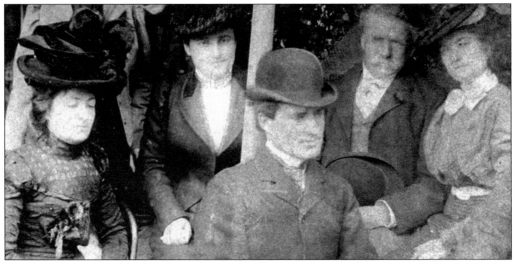

AMBROSE BIERCE (1842–?). Enter the cynic, Ambrose Bierce, whose biography is titled *Alone in Bad Company*. "Fierce Bierce" is seated second from right, and poet Herman George Scheffauer (1878–1927) is wearing a bowler hat in this photo taken in the Los Gatos area. The men were often surrounded by "young admirers." Bierce is best remembered for his devastating Civil War short story, "An Occurrence at Owl Creek Bridge," and for his wickedly funny and jaundiced work, *The Devil's Dictionary*. For 20 years he wrote for William Randolph Hearst's *Examiner*, his scalding pen passing judgment on the "fools and gasbags" he encountered, as well as the "Rail Rogues" of the day, including Leland Stanford. Bierce escaped to Los Gatos for his severe asthma and lived at the El Monte Hotel on East Main Street for periods of time in the 1890s. He was seen tramping over the hills with his dog and cane. At age 70, he vanished into revolution-torn Mexico and presumably died there.

JOHN (1902–1968) AND CAROL (1906–1983) STEINBECK, C. 1935.

Steinbeck was working on *Of Mice and Men* in May 1936 when he and his wife Carol purchased a 1.6 acre plot of oak and manzanita from local realtor Effie Walton. They built a home on Greenwood Lane, about a mile from Los Gatos. Here Steinbeck wrote *The Grapes of Wrath*, a literary masterpiece and a microcosm of the California experience, which won the Pulitzer Prize in 1940 and the Nobel Prize for Literature in 1962. Steinbeck didn't often mingle with the people of Los Gatos, but was known to have a drink at the Lyndon Hotel Bar. He drove a four-door touring car, his hair whipping in the wind as he traveled through town. He credited Los Gatos physician Dr. Horace Jones for improvement of his sciatica. In 1938, the Steinbecks, complaining of noise and nearby development, left Arroyo del Ajo (Garlic Gulch) on Greenwood Lane, and moved to a ranch in the Santa Cruz Mountains, where he was sometimes referred to as "the moody country gentleman of Moody Gulch." (Used with permission of Sharon Brown Bacon and the Center for Steinbeck Studies, San Jose State University.)

NEAL CASSADY (1926–1968). In August 1954, Neal and Carolyn Cassady purchased a ranch house on Bancroft Avenue, "in the middle of prune orchards, yet only a mile from Los Gatos village." Neal Cassady, at the center of the Beat Generation, appears as a main character in many books, most famously as the irrepressible "Dean Moriarty" in Jack Kerouac's *On the Road*. Kerouac, Allen Ginsberg, Ken Kesey, and Lawrence Ferlinghetti were frequent visitors to the home. Cassady worked as a brakeman and conductor for the Southern Pacific Railroad and stands at the right in this undated photograph. In 1958 he was sentenced to San Quentin for selling marijuana. In her autobiography, Carolyn Cassady expressed gratitude for the support she and her three children received from the community and for sympathetic reporting by Sam Hanson for the *Los Gatos Times–Observer*. After his release from prison in 1960, Cassady worked at the Los Gatos Tire Company. A brilliant but tormented man, often involved with drugs, Neal Cassady died of unknown causes in Mexico, recalling the death of Ambrose Bierce more than 50 years earlier.

LGHS Student Body Officers, 1932. The race for student body office in 1932 was a close one, with the following results, left to right: treasurer Orion Kellam, secreatary Olivia deHavilland, president Remo Cacitti, vice president James Gibb. Olivia de Havilland was born to American parents in Japan in 1916. She came to the United States at the age of four with her mother and sister, Lillian and Joan Fontaine. She grew up in Saratoga and graduated from Los Gatos High School in 1934. Lillian encouraged both her daughters in their pursuit of acting, but her stepfather considered it a "silly distraction." When she was chosen to play a lead in the junior class play, he gave her an ultimatum to either withdraw from the play or leave the house. The plucky young actress lived her senior year at the Saratoga Inn. By 1935 she was under contract to Warner Brothers in Hollywood.

Olivia in Los Gatos. A short five years after graduating from LGHS, Olivia de Havilland was loaned from Warner Bothers to MGM to play the part of Melanie Hamilton in David O. Selznick's *Gone with the Wind* (1939), one of the most popular and beloved pictures ever to grace the silver screen. She earned an oscar nomination for best supporting actress for that role and won oscars for best actress twice, in *To Each His Own* (1946) and *The Heiress* (1949). Although she has lived in Paris since the 1950s, she has periodically returned to Los Gatos and Saratoga and gave the commencement address at the 1988 Los Gatos High School graduation, in celebration of the school's 100th anniversary. She is pictured here, at right, while in Los Gatos for that event. At left is Mrs. Horace Jones.

USO Tour, 1944. This photo captures Olivia de Havilland and Yehudi Menuhin, both on tour visiting soldiers in the Aleutian Islands during World War II. Menuhin was an internationally renowned violinist and conductor who performed hundreds of concerts for Allied soldiers and war-related charities. In 1942 he presented a "gift concert" in Los Gatos for soldiers stationed in the town. After the war, he performed in Germany as a gesture of reconciliation. In his early years he lived in Los Gatos with his parents, Moshe and Marutha Menuhin, a time he characterized as "blithe, young, joyful, and golden." As an adult he maintained a beloved estate in the hills east of Lexington Dam. He became a citizen of England and was knighted by Queen Elizabeth II. He died at age 82 in Berlin, where he had gone to conduct.

Nana-Ruth Gollner (1919–1980). Born in El Paso, Texas, this famous dancer overcame childhood polio to become the first modern American ballerina to achieve the rank of prima ballerina in a European ballet company. The Gollner family moved to Edelen Avenue in Los Gatos, and Nana attended the old University Avenue Elementary School and danced in school shows. In her teen years she performed with the Ballet de Monte Carlo and later danced with the American Ballet Theater and the London-based International Ballet. She appeared on the cover of *Life* magazine March 20, 1944. (Courtesy of the Museums of Los Gatos.)

"Broncho Billy" Anderson

(1880–1971). Gilbert M. Anderson (real name Max Aronson) was a motion picture pioneer. As a 23-year-old novice, he played three small roles in *The Great Train Robbery*. He began to star in westerns in 1909 for the Essanay Film Company, which he had formed with a partner. In 1910 the film company arrived in Los Gatos. In a letter to the *Los Gatos Times* in 1958, he recalled filming in a ceilingless set behind the Hotel Lyndon, the better to catch the sunlight, and relaxing on the "big rambling porch after a tiresome day up in the mountains taking a picture." College Avenue was sometimes used to shoot stage coach footage. Anderson complimented the people of Los Gatos and Alma, saying they showed great hospitality and cooperation in making the movies. Many locals who were fine horseback riders volunteered as extras. In 1958 Anderson received an oscar for his pioneering work, and he lived to be 90 years old.

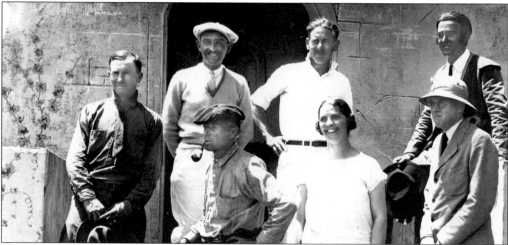

Looking Like Hollywood. On the site of the old Los Gatos Cooperative Winery, and directly behind the current Civic Center, a natural amphitheater provided the setting for the Los Gatos Pageants, which ran for 12 consecutive summers, 1919 to 1930. The pageants were first conceived by Wilbur Hall, a Los Gatos writer and director, and were lighted by bonfires and flares. The acoustics in the outdoor setting were said to be remarkable. Facing the stage was the Town Bowl, which could hold up to 3,000 spectators, seated on rough planks supported by prune boxes. This photograph shows participants in the June 1924 production of "El Gato de Los Gatos," set in about 1830. On the upper row, from left to right, are Harry Pierce, Cecil Dickinson, Wilbur Hall, and Henry C. Crall, playing a dashing Spaniard, Senor Juan Ramon. On the front row are Gus Goehner, Mrs. Wilbur (Ruth) Hall, and Sen. Sanborn Young.

THE PAGEANT OF FULFILLMENT, JUNE 21, 1919. The theme of this production was the development of man from darkness to civilization. Entertainment started at 2 p.m. with a band concert on the plaza in front of Hotel Lyndon. Mayor William F. Godfrey gave the welcome, followed by a baseball game between the Bean Spray Pump Company and the Los Gatos Firemen, which the firemen won, 8–7. Tennis tournaments were held at Osburn Court and Case Court. In late afternoon, automobiles paraded to Glen Ridge Avenue for an "auto hill climbing contest." The "water nymphs" pictures here are, in uncertain order, Dorothy Patterson, Rachael Riggs, Ruth Wright, Nellie Berryman, Esther White, Charity Bowdich, and Blanch Lidley. Tickets were 50¢ plus war tax. About a week later, motion pictures of the pageant were shown at the Strand Theater.

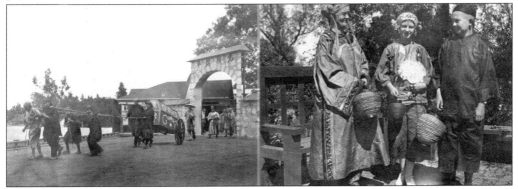

KEANG FOO, THE EXILE, JUNE 24–25, 1921. This elaborate production was adapted by Wilbur Hall from a Chinese classic, and Henry C. Crall, home from serving in the army in France, starred as the deposed prince. Nearly 500 people comprised the cast. Members of the Chinese Delegation from San Francisco arrived "by machine" to see this show and attended dinner afterwards at the Chinese-style home of Ruth Comfort Mitchell and Sanborn Young. Pictured at right are Lucy (1882–1957), Mary, and Bill Balch.

TRAIL DAYS, 1940. After presentation of *The Magic Lamp* in 1929 and *Gypsy Knight* in 1930, the pageants were suspended for the years of the Great Depression. In 1937 Ruth Comfort Mitchell wrote *Ten Episodes* to recall "the romance of the early days" and celebrate the Golden Jubilee of the incorporation of Los Gatos. For the big 1940 celebration of the completion of the Los Gatos–Santa Cruz highway into town, local author Owen Atkinson penned *Trail Days*. The Pageant Bowl had been improved with WPA labor. False fronts were erected on town businesses so they would appear as they had in 1890. New names were assigned, such as "Falaschi's End of the Trail Saloon," and "Crider's Trading Post." This photo, by Austen Meek, shows a bandit, played by Rolf Conwell, dashing across stage on his palomino, intent on snatching tollgate receipts from gatekeeper Prentiss Brown, then principal of LGHS. The man in the suit and hat is L.B. Peck. John Lincoln, mayor of Los Gatos from 1962 to 1966, is brandishing a Civil War sword for his role as Sergeant Jackson of the California Rifles. (Courtesy of the Museums of Los Gatos.)

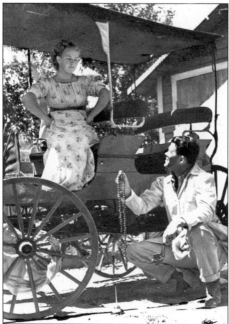

TRUE LOVE. In this scene from *Trail Days*, Molly Strange (Barbara Gibson) tells Dan O'Mally (John Baggerly) to "get a horse." It all worked out nicely, as Barbara and John, who were scripted to fall in love, did so in real life and were married for 58 years. Miss Betty McClendon directed the dance numbers and Dude Martin's Orchestra played for the street dance on Saturday night. In 1941, *The Pageant of the Hills* told a story of gold buried near the Rancho de Los Gatos by an early padre traveling on foot to Mission Santa Clara. Soon war news crowded every issue of the local newspapers. The devastating price of World War II had come home, with photos of young Los Gatans killed or missing in action on the front pages of many issues. Three more pageants were given—*The Cats* in 1946 by local writer Dean Jennings, *Dick Whittington's Cat* in 1947 by novelist Kathleen Norris, and *The Los Gatos Centennial Pageant* in 1987 by Kathryn Kapp Morgan. (Courtesy of Barbara Gibson Baggerly.)

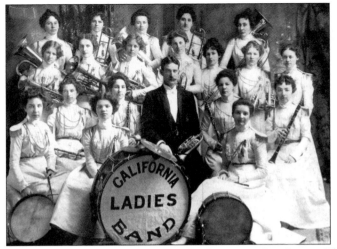

CALIFORNIA LADIES BAND. In 1898, Fred Brohaska gave the Santa Clara Valley the distinction of the first ladies band in the West, a novel and daring departure for the time. The band financed their own instruments and uniforms, and included many members from Los Gatos. In 1900 they appeared at The Pavilion, a "very imposing front" erected at the Los Gatos Canneries at 57 North Santa Cruz Avenue. In 1901 they performed for President McKinley's visit to San Jose. Pictured left to right are (first row) Georgia Saunders, Isabell Huber, Ethel Height; (second row) Laura La Montagne, Julia La Montagne (Mrs. Wm. Clelland), Fred Brohaska, Rachael Rosenberg, and Mrs. Agnes Currier; (third row) Camille Stockton, Edith Huber, Minnie Tupper, Stella Hoard, Delia Macabee, Mrs. Libby Weaver, and Mrs. Clara Holliday; (fourth row) Mrs. Edward Macabee, Mrs. Clarisse Walker, Mary Macabee, Tillie Brohaska, and Flora Macabee. The band's most popular number was "'Tis Not True," featuring a cornet solo by Miss Stella Hoard.

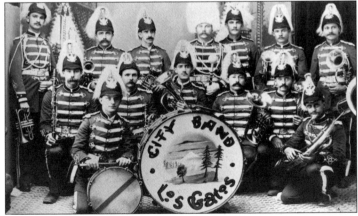

LOS GATOS CITY BAND. The band organized in 1883 but dissolved in 1885 "due to financial constraints." They organized again in time to perform at the town's 1898 Memorial Day exercises, but once again disbanded. Reorganized in 1905, "the boys" met for practice in the old stone mill and later at the Hose House, using their own instruments. Within one month of forming, the band gave a concert. "Some of the boys were acquainted with their instruments, some were absolute beginners," noted the newspaper. On July 15, 1905, they played at the post office and moved on to the El Monte Hotel, where they received a "sumptuous supper" for their efforts. They gave open-air concerts in front of the Lyndon Hotel, played at the Ford Opera House, and performed at Bunker Hill Park.

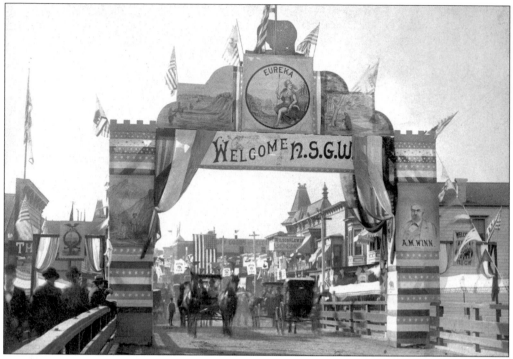

LOS GATOS LOVES A PARADE! In 1848, California was ceded to the United States by Mexico in the treaty of Guadalupe Hidalgo and became the 31st state on September 9, 1850. The September 9, 1892, Admission Day Parade in Los Gatos drew 7,000 visitors, many arriving on special trains to celebrate. The visitors were joined by members of the local parlors of the Native Sons and the Native Daughters of the Golden West in this parade along Main Street. The decorated archway at the west entrance to the wooden Main Street bridge bears the portrait of Albert Maver Winn (1810–1883), a California pioneer who founded those organizations.

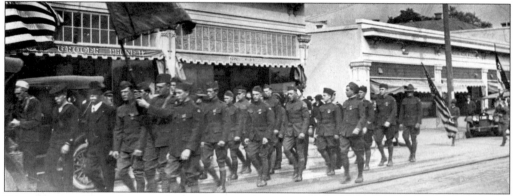

DOUGHBOYS. This photograph captures an Armistice Day parade down North Santa Cruz Avenue, headed south toward Main Street. The Interurban street car tracks are clearly visible. During World War I, Los Gatans subscribed for War Savings Stamps, planted gardens, and organized a Los Gatos Chapter of the American Red Cross. A Home Guard unit was established, open to any man between 18 and 60 years of age. Housewives were informed by the Los Gatos Merchants Association that only four deliveries would be made each day, rather than 15 or more, as had been the custom. (Courtesy of the John Baggerly Collection, *Los Gatos Weekly Times.*)

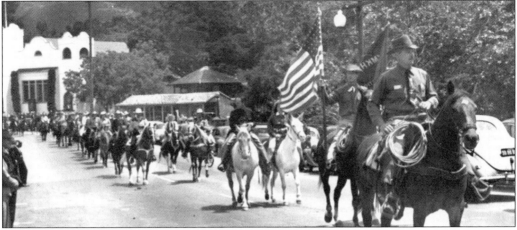

LOS GATOS GYMKHANA ASSOCIATION. Horse enthusiasts organized in 1940 for the purpose of sharing their interests in owning and training horses. An arena was set up along Los Gatos Creek for horse shows and competitions. Los Gatos parades during this period featured up to 200 horses. At far left is the Baptist Church, built in 1917 and demolished in 1958 in favor of the Penthouse Apartments. In 1953, the Gymkhana lost the use of the land along the creek, and the organization phased out. (Courtesy of the John Baggerly Collection, *Los Gatos Weekly Times*.)

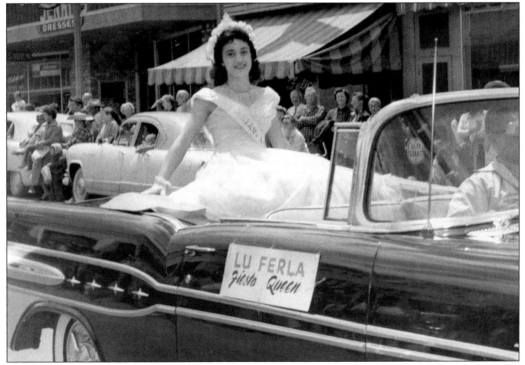

HAPPY DAYS. The pageants were gone, but Los Gatos celebrated with a Spring Festival Parade on April 3, 1954. Post-war prosperity was in full bloom, even as the orchards had begun to disappear. Worries of the day included the Lexington Dam, which many feared was dangerous in its location just above town, and the numerous annexations of land by San Jose, which included the site of the Los Gatos Cemetery. Lu Ferla reigned as 1954 Fiesta Queen. The photo was taken by Jerry Sheridan. (Courtesy of the John Baggerly Collection, *Los Gatos Weekly Times*.)

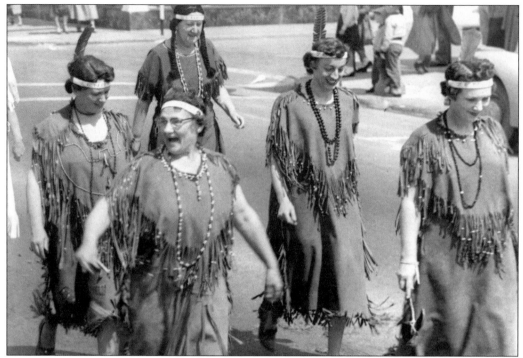

ZENETTA COUNCIL NO. 158, DEGREE OF POCAHONTAS, LOS GATOS. This group won the trophy for "Best Adult Marching Group" in the 1954 parade. The male branch of this fraternal and charitable organization is the Improved Order of Red Men. Los Gatos Pocahontas was organized on June 30, 1916, with a charter list of 33 members. The first to hold the office of Pocahontas was Josephine Rice. Pictured clockwise, from lower left, are Daisy White, Lena Barbieri Conley, Ruby White, Inez Means, and Pearl Hoehn. (Courtesy of the John Baggerly Collection, *Los Gatos Weekly Times*.)

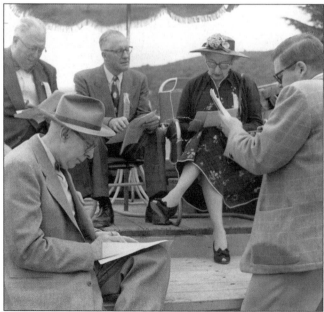

PARADE JUDGES. Judging entries in the 1954 Los Gatos Spring Parade are, left foreground, Frank Fisher, and right, Alex Wilson. In the back row, from left to right, are Paul Straub, manager of the Los Gatos PG&E; Raymond Fisher, principal and later superintendent of Los Gatos Elementary Schools from 1928–1959; and Effie Walton (1884–1969), real estate agent and developer of "Little Village" retail center. (Courtesy of the John Baggerly Collection, *Los Gatos Weekly Times*.)

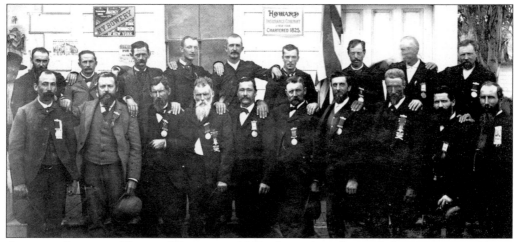

ANCIENT ORDER OF UNITED WORKMEN, 1883. A number of town fathers are pictured here, including James Lyndon (1847–1912) in the front row on the left. Born in Vermont, he fought with the Twenty-first Massachusetts Infantry in the Civil War, at the battles of Spottsylvania and Cold Harbor. He arrived in Los Gatos via Panama in 1868. At first he clerked for his brother John, then went into the lumber business. He was elected sheriff of Santa Clara County and served from 1894 to 1898. From left to right are (front row) James Lyndon, Thomas Cleland, Thomas Jenkins, William Lingley, John Erickson, William Spencer, Thomas Cox, Jacob Sacket, Harry Ball, and Fred Taylor; (back row) Robert Green, Frank Jackson, L.A. Cole, Fred Suydam, Lewis Trailer, Jules Shannon, George Bailey, Frank Reynolds, and Herman Sund.

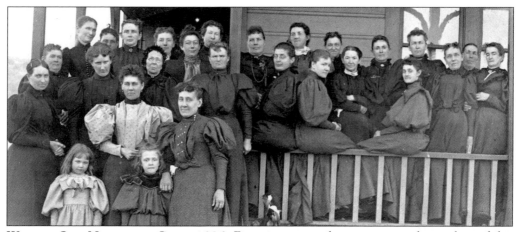

WE AND OUR NEIGHBORS CLUB, 1896. Five pioneer ranch women were the nucleus of this social club, founded in 1891. By horse and buggy they arrived at their meetings on the third Saturday of each month. In 1910 the club constructed a new clubhouse at the corner of Union and Almaden Road. From left to right are (front row) Mrs. Maria P. Schofield, president; Mrs. Julia Farrell; and Mrs. Ella Heywood. The children are Florence Cilker and Helen Stanfield. On the second row are Mrs. Alice Hamilton, Mrs. Aurie McCarthy, Mrs. Emma Loosemore, Mrs. Amanda Webster, Mrs. Emma Staus, Mrs. Flora L. Riggs, Mrs. Harriet B. Windsor, Mrs. Sue M. Stanfield, Mrs. Phoebe Riggs, and Mrs. Adalaide Francis. On the third row are Mrs. Anna Ellis, an unidentified guest, Mrs. Lottie Laurence (the day's hostess), Belle Armstrong, Mrs. Nellie Ford, another unidentified guest, Mrs. Ann Jane Cilker, Mrs. Wythe, Mrs. Bertha Follett, Mrs. Emma Comer, Mrs. Elizabeth Howes, and Mrs. Sophie La Montagne.

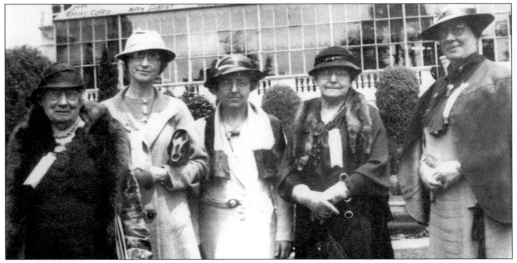

THE HISTORY CLUB OF LOS GATOS, 1907. Mrs. Richard A. Urquhart gathered together six women in 1897 to study history, ancient and modern. Over the years, the goals of the organization grew from the study of history to include a wide range of civic improvements. The club was incorporated in 1907, and charter member Miss Emily Cohen was elected president, an office she held for a nearly a quarter of a century. She was also a member of the library board from 1905 to 1935. Every year since 1897, the town asked the club to decorate the town square for Christmas, which they did by putting up a cut tree. In 1923, they planted a live tree which still stands, bringing joy to the center of town each year. From left to right are Miss Emily Cohen, Mrs. Mary Gilbert, Miss Elizabeth Smith, Mrs. Seymour Roberts, and Mrs. James Mason. (Courtesy of the History Club of Los Gatos.)

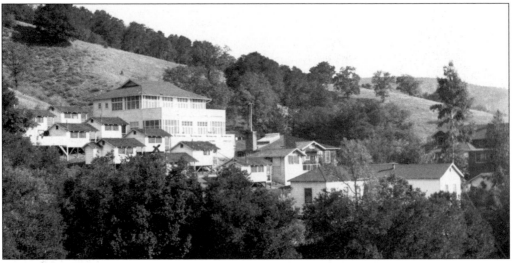

THE OAKS SANITARIUM. Doctors often sent patients suffering from respiratory problems to Los Gatos to prolong their lives. A number of large homes were converted to sanitariums to receive the sick, including those with tuberculosis and severe asthma. The Oaks Sanitarium on Montevina Road was the best known of many facilities. Los Gatos' reputation as a healing place was reinforced when the British medical journal, *The London Lancet*, declared in 1905 that Los Gatos, along with Aswan, Egypt, had "the most equitable climate in the world." For many years the *Lancet* quote adorned the masthead of the *Los Gatos Mail News*.

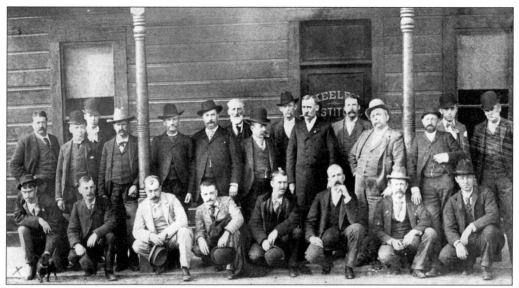

KEELEY CURE INSTITUTE. In late 1891, the Keeley Institute began business in this new building on the north side of East Main Street, near the site of today's recreation center. Founded by Dr. Leslie E. Keeley, it was established for the "treatment and cure of the opium, liquor, and tobacco habits, through the exclusive use of Kr. Keeley's preparation of double chloride of gold remedies." During 1892, of those "taking the cure," were 1,000 people, which included about 50 from Los Gatos. When the business closed in 1895, the local newspaper reported that "hard times interfered very largely with the liquor habit, being itself a cure." The building then served as Town Hall until the new Town Hall opened in 1913. This building was demolished in 1924.

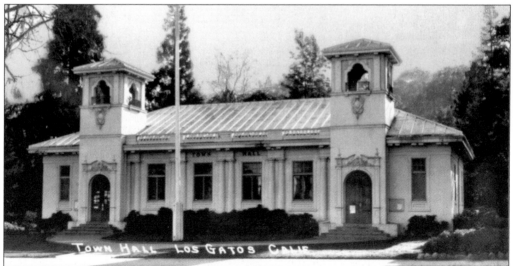

TOWN HALL (1913–1965). Many Los Gatans were sorry to see this classic building with double belfry torn down, when it was replaced with the current Civic Center complex. In 1937, Town Clerk Donna M. Winning, working at this location, wrote an article about some of the most interesting town ordinances, such as No. 10, which provided that horses, mules, and oxen travel at a walk when crossing the wooden bridge. An 1890 ordinance forbade horses or cattle being led along the sidewalks of the town, nor were they to be staked to the wooden sidewalks.

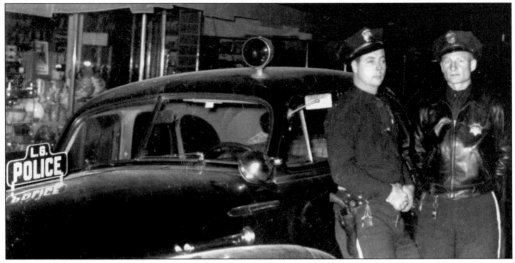

LOS GATOS POLICE DEPARTMENT. In 1932, the police force consisted of the chief of police and two officers, each of whom had to furnish his own gun, ammunition, uniform, and automobile. The first patrol car was purchased in 1937. During that era, a red light at the Bank of America corner at Main Street and Santa Cruz Avenue signaled when an officer was needed. Seeing the light, the officer would go to the nearest phone and call in to the telephone supervisor for the message. In this c. 1939 photo, Officer Walt Phillips is at left and Officer John Covalesk is on the right. Officer Covalesk was killed in 1950 after he had joined the San Jose Police Department and walked in on a robbery in downtown San Jose. (Courtesy of Detective Sergeant Mike Barbieri, Los Gatos–Monte Sereno Police Department.)

PROVINCIAL JAILHOUSE. The "sweatbox" jail that so briefly held Incarnation Garcia in 1883 burned down in 1896. This two-room accommodation, which faced Pageant Way and served from 1934 to 1965, was constructed mostly to care for "the drunks arriving on the late cars" at the railroad station. Because of their condition, they couldn't be taken to their homes, and the county jail was too far away. Children sometimes peeked through the bars to see the "bad guys." (Courtesy of the Museums of Los Gatos.)

A STEADY JOB. After Ralph Phillips graduated from Los Gatos High School, he worked at the old Bailey Lumber Company on South Santa Cruz Avenue and intended to make lumber his career. He joined the force in 1932 when the opportunity came along, thinking it would be steady work, especially during the depression years. Thirty-seven years later he retired, having served as police chief from 1943 to 1969. In 1943 his extra duties included serving as building inspector, tax collector, municipal health officer, and dog catcher. He is pictured here with "Miss Los Gatos" candidates in the 1950s. (Courtesy of the Los Gatos–Monte Sereno Police Department.)

LOS GATOS FIRE DEPARTMENT, C. 1937. In 1903, the town council agreed to pay 25 volunteer firemen the rate of $3 per fire, payable twice a year. At that time, three hose carts and a hand-drawn hook-and-ladder wagon comprised the fire equipment available in the town. Bond elections provided for new La France fire trucks in 1915 and 1916. In June 1926, another bond issue approved $30,000 for a modern firehouse on the corner of Tait Avenue and West Main Street, pictured here. Bud Lord, the town's first paid fireman, is on the left. He and his family lived at the firehouse. Bill Lyndon is at right. In 1970 the LGFD merged with the Santa Clara County Central Fire Protection District, and the building now serves as the Art Museum of Los Gatos.

POSTAL INSPECTION. From its first location at the Ten Mile House in the 1860s, the Los Gatos Post Office has moved many times. In this 1950s photograph, postal clerk Gordon Stouffer sorts mail under the watchful eyes of children from the Los Gatos Cooperative Nursery School on Lyndon Avenue. The current post office building was dedicated in 1966. (Courtesy of the Museums of Los Gatos.)

THE POUNDMASTER. In July 1954 John Fox was photographed with a three-foot rattlesnake he killed only a few feet from the back porch of a house on Kennedy Road. The local newspaper reported that the snake has seven rattles. Newspaperman John Baggerly liked to recall a dog named Black Barney, who was often seen in the 1950s riding around town with the poundmaster. Fox knew the dogs of the town by name and gave them a lift or sent them in the direction of home when he found them out wandering. (Courtesy of the Museums of Los Gatos.)

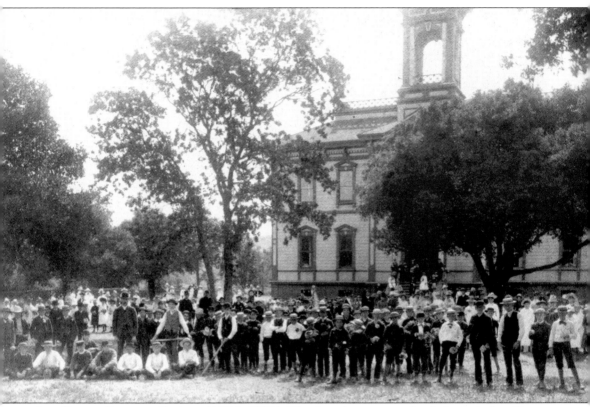

LOS GATOS CENTRAL SCHOOL (1886–1922). The first elementary-school classes in Los Gatos were conducted in a building on Oak Street (now Montebello Way). In 1863, an elementary school was built on property later belonging to the Cleveland Estate on Saratoga Avenue. The first one-room schoolhouse on School Street (now University Avenue) appeared in 1875, and that plot of land continued as a school site until 1961. A second small building on School Street was completed July 30, 1881, at a cost of $920. Ninety-eight students began studies on August 8 that year. In 1886, the school pictured here, designed by local architect William Lobdell, was constructed at a cost of about $9,000. It had 15-foot high ceilings, blackboards completely around the four classrooms, and white cedar stairway handrails capped with black walnut, to go with the fine black walnut newel posts finished in oil. Two sinks with faucets were on the first floor, one for boys and one for girls. One linen towel, one tin cup, and one comb were fastened to each sink by chains. The school grounds were "well-drained by underground redwood boxes." The classrooms were ventilated by large transoms opening into the corridors, and the rooms were furnished with simple "Star Bent" wood seats and teachers' cabinet stands. Henry Meade Bland, future California poet laureate, taught here from 1887 to 1889. In 1891 a printed notice forbade tying horses to trees in the schoolyard. But people persisted, and they also tied them "inside the shed, intended for the use of the school children."

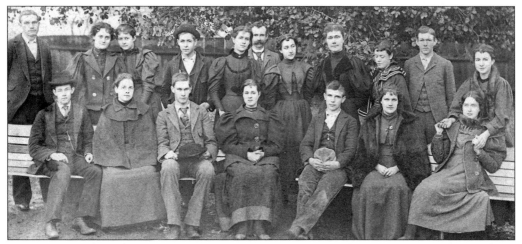

SECOND YEAR CLASS, LOS GATOS HIGH SCHOOL, 1895. In 1893 a contract was let for about $6,000 to build an addition on the south side of Central School, to house the high school studies program already underway. School was closed for a week in October 1893 to facilitate the moving of the two original one-story wooden structures 25 feet north, to make room for the new addition. The two old buildings housed first and second grade. The first high school graduating class in 1896 consisted of ten students who had completed a three-year course. The graduating class of 1897 had completed a four-year course and included many of those pictured here as second year students in 1895. The first edition of the *Wild Cat* yearbook was also published by the class of 1897. From left to right are (front row) John Crummey, Erma Simon, Edward Waller, Jane Willis, Frank Foster, Myrtle Sporleader, and Jennie Tobin; (back row) Arthur Waller, Harriette Sage, Jennie Mirriam, Nat Symonds, Dora Johnson, Mr. Kelley, Myrtle Roberts, Miss Martha Cilker (teacher), Ruth Killam, Fred Lobdell, and Amy Irene Milberry.

LOS GATOS HIGH SCHOOL (1908–1924). By 1906 the desire for a high school building separate from the grammar school, located on a different site, was expressed. A $30,000 bond was passed on January 17, 1907, for a new high school building, which opened in 1908. It stood at the crest of High School Court, and the land fronting on Main Street was purchased in 1911. The building showed California Mission influence and was located approximately where the high school library presently stands. When a new high school was built in 1925, the old building was retained and used for classrooms and industrial shops. Sections were torn down over the years, until none of this building remained by 1955. (Courtesy of the California Room, San Jose Public Library.)

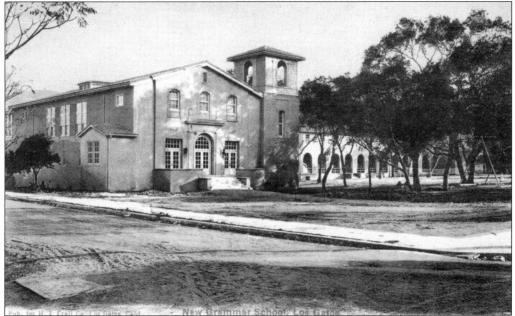

UNIVERSITY AVENUE GRAMMAR SCHOOL (1923–1961). This postcard, published for the H.J. Crall Company, shows the "New Grammar School" in Los Gatos. In 1909, the local newspaper had reported that the lavatory facilities at the old Central School had been condemned as a nuisance by the Board of Health. That building was located at the back of the primary grade buildings, with a door at each end and a long row of seats across the back. It wasn't until 1923 that a new school opened, one which was styled after the Mission San Juan Capistrano. University Avenue School served as a public grade school until 1961 and reopened as the Old Town Shopping Center in 1964.

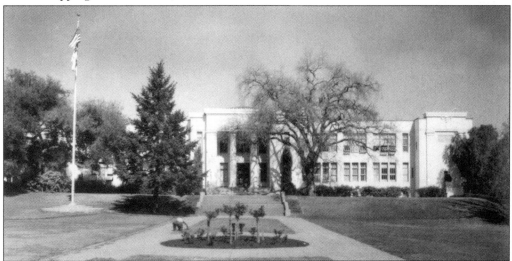

LOS GATOS HIGH SCHOOL, CONSTRUCTED 1925. Due to increased enrollment and the desire for a gymnasium, a bond measure for $250,000 to finance a new high school was passed in 1923. January 17, 1925, was dedication day for the new facility, which still stands on the rise of lawn facing Main Street. The gymnasium was also completed in 1925. Since that time the campus has continued to grow and change, but has maintained its classic look.

CHAUTAUQUA IN LOS GATOS. The first Chautauqua was held in Los Gatos in 1916, presented by the Ellison-White Chautauqua System. A season ticket cost $2.50 plus war tax. On the afternoon of May 30, 1918, William Jennings Bryan delivered a patriotic speech in a tent that could accommodate 1,400 people, located on a vacant block on Santa Cruz Avenue, during the time when America was heavily embroiled in World War I. The program cover pictured here is from the 1919 Chautauqua, which offered a series of presentations including a talk by Adam Bede, editor, humorist, and statesman; "Private Peat," telling of "Two Years in Hell and Back With a Smile"; a lecture titled "Woman's Work in Reconstruction" that addressed the place of women once "our boys" returned from World War I; and a concert by Jaroslav Cimera and his Czecho-Slovak Band. Many programs were presented in the Ford Opera House. By 1924, interest in Chautauqua had waned, and Los Gatos concentrated on the summer pageants.

MING QUONG HOME. Beginning in 1874 Donaldina Cameron and a group of Presbyterian churchwomen began a crusade to save young Chinese slave girls from a life of prostitution in San Francisco. She opened her first mission in that city, a safe shelter for girls whom she herself sometimes rescued from the back alleys and secret underground passageways of Chinatown. In 1935 the Ming Quong home of Los Gatos opened at the former Richard Spreckles estate at the top of Loma Alta Avenue, and the annual Strawberry Festival benefit commenced in 1936. The Spreckles home had for a time served as a hospital after the 1929 stock market crash caused the family to leave. "Ming Quong," which means "radiant light," was successful first as an orphanage, then as a boarding school. It serves effectively today as Eastfield Ming Quong, providing child and family mental health services in Santa Clara County. The photo was taken by Norman Fong. (Courtesy of the Museums of Los Gatos.)

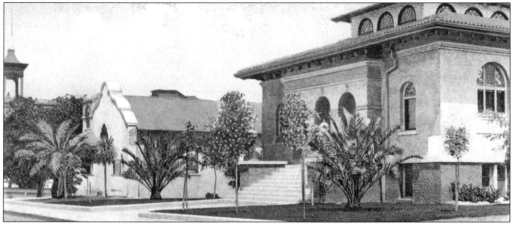

LOS GATOS CARNEGIE LIBRARY (1903–1954). In 1898 a small library was established in the back of a store of East Main Street, "on stilts, over the creek," which had an average daily attendance of 50 people. The WCTU and the Floral Society supplied the books. E.L. Ford, station agent for the Southern Pacific Railroad, wrote to Andrew Carnegie (1835–1919) in 1901, requesting money for a library building for Los Gatos. Carnegie, a Scottish immigrant who had made a fortune in steel, endowed more than 1,600 public libraries in the United States, believing them to be "ladders upon which the aspiring can rise." Carnegie sent the town $10,000, and the library pictured here opened its doors on September 25, 1903. It was located on University Avenue on land that now serves as the Episcopal Church's parking lot. St. Luke's Episcopal Church is to the left, reconstructed after the 1901 fire, and on the far left is the tower of Los Gatos Central School.

THE CHILDREN'S CORNER. This photo was taken in 1906 inside the one-room Los Gatos Carnegie Library, at the request of the California State Library, and published in the *State Library Bulletin*, "to show other small libraries in the State what can be done for children without having a separate room for them, and as an incentive to other Librarians." Henrianna A. Rankin served as the town's librarian from 1904 to 1909. The basement of the building was "fitted up" as a children's room in 1919. The first library board included J.W. Lyndon, R.R. Bell, D.C. Crummey, B.P. Shuler, and W.H.B. Tranthan. An early town ordinance expressly forbade spitting tobacco juice on the library floor, stealing materials, and using profane language in addressing the librarian.

THE MONTEZUMA SCHOOL FOR BOYS (1910–1955). A school brochure reads, "Located in the Santa Cruz Mountains, near Los Gatos, Montezuma gives boys physical education through life in the mountains, and interesting outdoor work, and moral education, training in initiative, responsibility and self government." E.A. "Prof" Rogers was the school's founder and headmaster. The Junior Statesmen of America was founded here in 1934 and has grown to be the largest student-run high school organization in the United States. Montezuma School published a magazine titled *The Boy Builder*.

EARTHQUAKE! "AN AWFUL SHOCK–STRONG MEN SUFFER NAUSEA–WOMEN HYSTERICAL." Thus read the headlines of the April 20, 1906, edition of *The Los Gatos News*. The damage locally was not as severe as in San Francisco and San Jose, as evidenced by this photo postcard of a man seeking refuge in Los Gatos. However, fallen plaster, shattered glass, and raw nerves were plentiful. The La Canada entrance was cracked and displaced, and the Beckwith Building's keystone arch was "badly wrecked." A few walls fell down and the aftershocks went on for days. Many slept in tents in their yards. Ford's Opera House suffered the least, and its chimney, the tallest in town, "stands without a flaw." The *News* further reported that 25 little girls made homeless by the earthquake in San Francisco came to Los Gatos and were housed at the Hume Ranch. Dr. Yelland provided a cow for milk. Each child was given two dresses, two night gowns, two aprons, and a pair of overalls, to be worn with calico blouses made by members of the History Club. (Courtesy of William A. Wulf.)

MISS MARTHA E. CILKER, TEACHER. Martha Cilker taught in the new high school addition to the Los Gatos Central School in the 1890s. She was the daughter of John Cilker (1833–1909), who crossed the plains in 1857 to go to the gold mines at Placerville. He settled in the Santa Clara Valley in 1867 with his bride, Ann Jane Lipsett Cilker, a native of County Donegal, Ireland. John Cilker was a noted horticulturist who owned 174 acres of orchards and vineyards near Los Gatos. The Cilker land included the current site of Good Samaritan Hospital in San Jose. Martha Cilker, one of eight children, is remembered for setting high standards for her students. (Courtesy of the Museums of Los Gatos.)

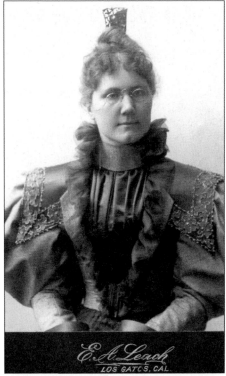

GENTLE PHILANTHROPIST. William C. Shore (1830–1905) left his home in Kansas City in 1849 at age 19, headed for the gold fields of El Dorado County. He came across the plains driving ox teams, a five-month journey. He mined for three years, farmed, and in 1881 came to Los Gatos and engaged in the retail ice business in 1884. The Shore family home site had an ideal setting along the banks of Los Gatos Creek, just south of the Main Street Bridge. The property was dotted with massive oak trees. In 1897 Mr. Shore donated land to the town for the creation of Bunker Hill Park. After World War I, the name was changed to Memorial Park, in honor of all war dead. Countless community celebrations and picnics flourished where Highway 17 now winds its way up the gap into Cats' Canyon. (Courtesy of Elayne Shore Shuman.)

FRANK H. MCCULLOUGH AND FRIENDS. Frank McCullough was a Los Gatos land developer who arrived in the 1880s from Pennsylvania. He was inseparable from his collie dogs, and is shown in this photo at the entrance to his estate at the top of Pennsylvania Avenue, at the intersection of Wissahicken Avenue. Both streets were named for his native area. Part of his orange grove is seen at left. On February 22, 1895, he wrote a letter to a local newspaper deploring the amount of shooting taking place on Glen Ridge, saying "a man couldn't plow a field without having to dodge a few charges of shot." (Courtesy of the Museums of Los Gatos.)

BILLY JONES (1884–1968). Billy Jones went to work for the Southern Pacific Railroad at age 13 and stayed for 50 years. He constructed his own "Wildcat Railroad" on the ten-acre orchard behind his Daves Avenue home in Monte Sereno and began regular runs in 1943. The backyard railroad ran almost every Sunday until 1967, giving thousands of children and adults the experience of riding on a puffing, stream-driven train. He is pictured here with his friend and fellow railroad buff, Walt Disney (left), who came to look at the Wildcat Railroad while planning for the Disneyland Railroad. Jones dedicated his railroad in memory of his two sons, both killed in World War II. After Jones' death, the railroad moved to Oak Meadow and Vasona Parks. (Courtesy of the John Baggerly Collection, *Los Gatos Weekly Times*.)

FRANKIE CROSETTI (1910–2002), NEW YORK YANKEE. Frankie was a member of Miss Louise Van Meter's first-grade class at University Avenue School, where the teacher pitched a ball to the student who solved arithmetic problems first. Frank often caught those balls, possibly the start of his long career playing shortstop for the Yankees, 1932–1948. Always and only a Yankee, he served as third-base coach for an additional 20 years. He played alongside Babe Ruth, Lou Gehrig, and Joe Di Maggio.

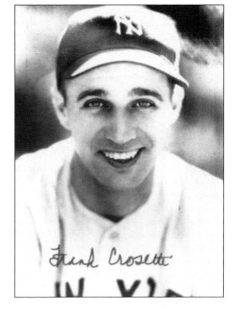

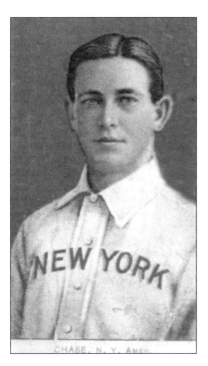

Prince Hal. Harold Homer Chase (1883–1947) was born in Los Gatos. One of the finest first basemen ever to play the game, he was also branded "Baseball's Biggest Crook." He was repeatedly accused of throwing games, bribing players, and betting against his own team. He was thought to be the mastermind of the 1919 World Series Black Sox scandal. In 1921, Baseball Commissioner Kenesaw Mountain Landis permanently banned Chase from baseball.

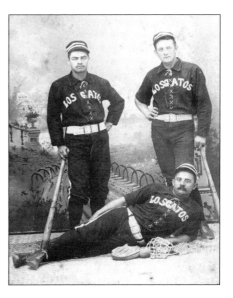

EARLY LOS GATOS BASEBALL. The names of these three Los Gatos baseball players are unknown. They are wearing laced-front jerseys with full collars, first introduced in the 1870s. A popular saying was "running bases, wearing laces." The style remained popular through the 1890s. The uniforms were usually made of wool. (Courtesy of Shirley Henderson.)

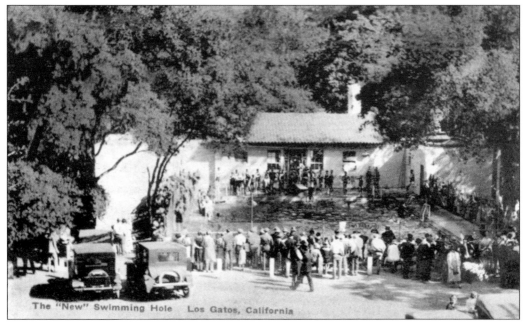

The "New" Swimming Hole Los Gatos, California

MUNICIPAL PLUNGE (1927–1954). Prior to this swimming pool in Memorial Park, a swimming hole in Los Gatos Creek just south of town dubbed the "Boogang" was popular with the boys of Los Gatos. The Boogang lost some of its appeal after the pool was built, and it disappeared completely with construction of Lexington Dam. At the pool, a patron obtained admission, a swimsuit, and a towel, all for a quarter. For many years, the park and its facilities at the foot of Park Avenue were a source of pride for the community.

TROUT FISHING IN LOS GATOS CREEK, 1906. "It's a complex fate, being an American," said Henry James. Many who came to California looking for gold in 1849 settled in spots such as Los Gatos when they discovered the riches were in the land, in the climate, and in the opportunity to work hard for great rewards. The pursuit of wealth opened other opportunities for living in an area that nature has looked kindly upon—and where the possibilities for a better life were well within reach.